AUTHENTICITY IN
THE ART MARKET

A Comparative Study of Swiss,
French and English Contract Law

Carolyn Olsburgh

Copyright: Carolyn Olsburgh and the Institute of Art and Law.
Published in Great Britain in 2005 by the Institute of Art and Law,
1-5 Cank Street, Leicester, LE1 5GX
Tel: 0116 253 8888; Fax: 0116 251 1666
E-mail: info@ial.uk.com

ISBN: 1-903987-18-0 (hardback); 1-903987-17-2 (softback)

TABLE OF CONTENTS

Table of Cases v
Table of Legislation vii
Preface ix
Avant-Propos xi

Chapter 1: Introduction 1
I. Definitions 2
II. Specificities of the Art Market 3
III. Scope, Structure and Method 4
 A. Scope and Limits of the Book 4
 B. Structure and Method 6

Chapter 2: Swiss Law 7
I. The Seller's Duty to Inform 7
II. The Guarantee of Authenticity 8
 A. Express Guarantee 8
 B. Tacit Guarantee 8
III. The Remedies of the Buyer (including the problem
 of limitation periods) 9
 A. Remedies Regarding the Formation of the Contract 9
 a. Erreur Essentielle 9
 i) Notion and Conditions 9
 ii) Consequences 12
 b. Dol 14
 i) Notion and Conditions 14
 ii) Consequences 15
 B. Remedies Regarding the Performance of the Contract 16
 a. The Seller's Liability for Defects 17
 i) Conditions 17
 ii) Consequences 20
 b. General Liability for Non-Performance? 21

Chapter 3: French Law 22
I. The Seller's Duty to Inform 22
II. The Guarantee of Authenticity 23
 A. Express Guarantee 23
 B. Tacit Guarantee 24
III. The Remedies of the Buyer (including the problem
 of limitation periods) 25
 A. Remedies Regarding the Formation of the Contract 25
 a. Erreur Essentielle 25
 i) Notion and Conditions 25
 ii) Legal Consequences 31
 b. Dol 33
 i) Notion and Conditions 33
 ii) Consequences 34
 B. Remedies Regarding the Performance of the Contract 34
 a. The Seller's Duty of Delivery 35
 b. The Seller's Liability for Defects 35

Chapter 4: English Law 37
I. The Seller's Duty to Inform 38
II. The Guarantee of Authenticity 39
 A. Statement of Opinion 39
 B. Term of the Contract 39
 C. Collateral Contract 43
 D. Representation 43
III. The Remedies of the Buyer (including the problem
 of limitation periods) 43
 A. Remedies Regarding the Formation of the Contract 44
 a. Mistake 44
 b. Misrepresentation 46
 B. Remedies Regarding the Performance of the Contract 49
 C. Excursus: the Trade Descriptions Act 1968 51

Chapter 5: Comparison and Evaluation of the Solutions 52
I. The Seller's Duty to Inform 52
 A. Comparison 52
 B. Evaluation 52
II. The Guarantee of Authenticity 53
 A. Comparison 53
 B. Evaluation 54
III. The Remedies of the Buyer 55
 A. Comparison 55
 a. Remedies Regarding the Formation of
 the Contract 56
 i. Mistake and Innocent/Negligent
 Misrepresentation 56
 ii. Dol and Fraudulent Misrepresentation 59
 b. Remedies Regarding the Performance of
 the Contract 59
 B. Evaluation 60
 a. Nullity/Rescission of the Contract 60
 b. Damages 61
IV. The Problem of Limitation Periods 62
 A. Comparison 62
 B. Evaluation 63

Chapter 6: Conclusion 66

Appendices
I. Table of Limitation Periods 69
II. Sotheby's Authenticity Guarantee and
 UK Conditions of Business 71
III. Christie's Conditions of Sale 74
IV. Translation of the Relevant Swiss Provisions 77
V. Translation of the Relevant Provisions of the
 French Civil Code 85
VI. French Decree No. 81-255 89
VII. Relevant Provisions of English Law 93

TABLE OF CASES

England and Wales

Ass'd Japanese Bank (International) Ltd v. Crédit du Nord SA 44, 45
Bell v. Lever Brothers Ltd 44, 45
De Lassalle v. Guilford 50
Derry v. Peek 47
Drake v. Agnew 39, 40, 42
Esso Petroleum Co. Ltd v. Mardon 47, 50
Great Peace Shipping Ltd v.Tsavliris Salvage (International) Ltd 44, 45
Harlingdon & Leinster Enterprises Ltd v. Christopher Hull Fine Art Ltd 38, 40, 41, 43, 51
Harrison & Jones Ltd v. Bunten & Lancaster Ltd 44
Hedley Byrne & Co Ltd v. Heller & Partners Ltd 47
Hoos and Others v. Weber 42, 43
Jendwine v. Slade 39, 40
Leaf v. International Galleries 40, 43, 44, 45, 48, 49, 50, 51
Lomi v. Tucker 43
May v. Vincent 51
Nicholson & Venn v. Smith-Marriott 45
Ojjeh v. Waller 42
Oscar Chess Ltd v. Williams 40, 50
Peco Arts v. Hazlitt 39, 46
Power v. Barham 40
Sewhanberg v. Buchanan 43
Smith v. Hughes 37, 45
Smith v. Land and House Pty Corp. 43
Taylor Thomson v. Christie Manson & Woods Ltd 37
Techarungreungkit v. Götz 39
De Balkany v. Christie Manson & Woods Ltd 5

France
Cour de Cassation

Cass. 1ère civ., 1 Feb. 1960 34
Cass. 1ère civ., 16 Dec. 1964 (painting by Courbet) 24, 29
Cass. 1ère civ., 26 May 1965 (painting by Monticelli) 24
Cass. com., 20 Oct. 1970 28, 29
Cass. 1ère civ., 26 Jan. 1972 (painting by Magnasco) 24, 28
Cass. 1ère civ., 31 May 1972 (painting by Cezanne) 32
Cass. 1ère civ., 26 Feb. 1980 (sculpture of Tang period) 28
Cass. 1ère civ., 2 June 1981 (painting by van Ostade) 31
Cass. 1ère civ., 13 Dec. 1983 (painting Olympus and Marsyas by Poussin) 30

Cass. 1ère civ., 24 March 1987 (painting Le Verrou by Fragonard) 29
Cass. 1ère civ., 31 March 1987 (sculpture of Tang period) 24, 29
Cass. 1ère civ., 16 April 1991 (painting by Delacroix) 34, 36
Cass. 1ère civ., 7 Nov. 1995 (painting by Herbin) 23
Cass. 1ère civ., 14 May 1996 25, 36
Cass. 1ère civ., 13 Jan. 1998 (pastel by Cassat) 28
Cass. 1ère civ., 3 May 2000 22, 33
Cass. 1ère civ., 5 Feb. 2002 (work by Spoerri) 29
Cass. 1ère civ., 3 April 2002 (painting by Monticelli) 23
Cass. 1ère civ., 6 Nov. 2002 25
Cass. 1ère civ., 17 Sept. 2003 (painting La Fuite en Egypte by Poussin) 28
Cass. 1ère civ., 25 May 2004 31
Cass. 1ère civ., 22 June 2004 33
Cass. 3ème civ., 17 Nov. 2004 25
Cass. 1ère civ., 14 Dec. 2004 36

Cours d'Appel

CA-Rennes, 17 June 1929 (painting by Nattier) 24
CA-Paris, 12 Feb. 1954 (painting school of Botticelli) 24, 31
CA-Paris, 1 Feb. 1966 (painting by Ruysch) 31
CA-Paris, 15 June 1981 (painting by Gauguin) 28
CA-Versailles,13 April 1983 22, 27
CA-Versailles, 7 Jan. 1987 (Poussin, final decision) 26, 28
CA-Paris, 24 Sept. 1987 (painting from Dutch and baroque period) 28
CA-Paris, 5 May 1989 28
CA-Paris, 15 Nov. 1990 22
CA-Versailles, 10 Feb. 1994 (print) 30
CA-Paris, 25 Feb. 1994 28, 30
CA-Versailles, 15 May 1997 31
CA-Paris, 27 Feb. 1998 (painting by Poussin) 24
CA-Paris, 7 May 2001 (painting by van Gogh) 30, 31

Tribunaux de Grande Instance

TGI-Paris, 30 Nov. 1967 34
TGI-Paris, 7 May 1975 (painting type of Marieschi) 24
TGI-Tarascon, 10 Dec. 1999 (painting by Vlaminck) 28, 29
TGI-Paris, 3 May 2000 31
TGI-Paris, 31 Jan. 2001 (statue of Sesostris III) 29

Switzerland

Swiss Supreme Court:
ATF 52 II 143
(Chah Abbaz Persian carpet) 9, 11
ATF 56 II 424, Sem. Jud. 1931 p.
428
(painting by Léopold Robert)
 18
ATF 61 II 228, JdT 1936 I 84 15
ATF 81 II 56, JdT 1955 I 562 17
Sem. Jud. 1956 p. 272 11, 17
ATF 82 II 411, JdT 1957 I 182
 (painting by van Gogh)10, 12, 14, 16
Sem. Jud. 1961 p. 127 7
ATF 92 II 328, JdT 1968 I 34 7
ATF 94 II 26, JdT 1969 I 322 18
ATF 99 II 185, JdT 1994 I 46 18
ATF 102 II 97
(Stamp 'Helvetia Assise') 8, 18
ATF 107 II 231, JdT 1982 I 71 18
ATF 107 II 419, JdT 1982 I 380 21
ATF 109 II 433, JdT 1984 I 314 13
ATF 114 II 131, JdT 1988 I 508
(drawing by Picasso) 9, 11, 12, 13, 16,
 18, 21
ATF 116 II 431, JdT 1991 I 45 7
ATF 123 III 165, JdT 1998 I 2 8
ATF 126 III 59
(vase by Gallé) 9
ATF 126 III 426, JdT 1998 I 17 18
ATF 127 III 83, Sem. Jud. 2001 I
301 9
ATF 129 III 320, Sem. Jud. 2004
33 13
ATF 129 III 503, Sem. Jud. 2004 I
278 13
ATF 131 III 145 15

Cantonal Courts:
RJB 1965 p. 145
(painting by Albert Anker) 10, 13
RJJ 5-6/1995-1996 p. 141
(restoration of a clock) 8,
 10, 20
RSJ/SJZ 27/1930-31 p. 221 Nr 39
(commode Louis XVI) 10
RSJ/SJZ 37/1940-41 p. 233 Nr 156
(furniture Louis XV) 10
ZR 59/1960 Nr 122
(violin by Gagliano) 10
ZR 62/1963 Nr 35
(painting *Danseuses* by Degas) 10
ZR 66/1967 Nr 106
(painting by Vautier) 10, 11
ZR 68/1969 Nr 1
(painting *La Liseuse* by Degas) 10, 11

TABLE OF LEGISLATION

England and Wales

Limitation Act 1980
 s. 5 46, 50
 s. 32 46, 49, 50
Misrepresentation Act 1967

 s. 1 46, 48
 s. 2 47, 48
Sale of Goods Act 1979
 s. 11 49, 50
 s. 12 42
 s. 13 39, 42, 54
 s. 14 39, 42
 s. 15 42
 s. 29 62
 s. 35 48, 50
 s. 48A 49
 s. 48C 49
 s. 48F 49
 s. 53 50
 s. 61 49
Trade Descriptions Act 1968
 s. 1 51

France

1981 Decree 53, 55
 Art. 1 23
 Art. 2 23
 Art. 3 23
 Art. 4 24
 Art. 5 24

Civil Code
 Art. 1108 25
 Art. 1109 25
 Art. 1110 26, 32
 Art. 1116 33
 Art. 1117 31
 Art. 1150 35
 Art. 1151 35
 Art. 1184 35
 Art. 1304 32
 Art. 1382 22, 32
 Art. 1383 32
 Art. 1603 33
 Art. 1604 35
 Art. 1641 25, 35, 36
 Art. 1643 35
 Art. 1644 35
 Art. 1645 35
 Art. 1648 36
 Art. 2248 62

Art. 2262 32, 35
Art. 2270-1 33, 34

Switzerland

Act on the International Transfer of
Cultural Property 19
Civil Code
 Art. 2 7, 14
Code of Obligations
Art. 23 7, 9, 13, 16
 Art. 24 7, 9, 13, 16
 Art. 25 12
 Art. 26 14
 Art. 28 7, 14, 15, 18
 Art. 31 12, 13
 Art. 31 15
 Art. 41 15
 Art. 60 16
 Art. 62 13
 Art. 67 13
 Art. 97 8
 Art. 102 21
 Art. 107 21
 Art. 108 21
 Art. 109 21
 Art. 127 18, 21
 Art. 135 62
 Art. 141 18
 Art. 197 8, 16
 Art. 200 17
 Art. 201 17
 Art. 203 17
 Art. 205 20
 Art. 208 20
 Art. 210 18, 64
 Art. 210 (1 bis) 19

International

UNESCO 1970 Convention 19
United Nations Convention on
Contracts for the International
Sale of Goods 5

PREFACE

This work is a revised version of a thesis submitted as part of the degree of Master of Law at the University of Cambridge. I am grateful to Professor John Bell and Oliver M. Brupbacher for their suggestions, comments and assistance on earlier drafts of the work; however, responsibility for any errors or omissions remains my own.

Authenticity of works of art is becoming ever more important in practice: increased interest in art, in particular as an investment, results in soaring prices, and the collector's desire to own a 'genuine' work is paramount. However, the courts of the three jurisdictions studied here take differing paths to resolve disputes as to authenticity between buyers and sellers; these differences are explained and analysed in this work, with a view to guaranteeing more effectively protection of the buyer. It is suggested that works of art should not be treated merely as another form of chattel, but regard should be had, when seeking to resolve disputes, to the special nature of these works. The international nature of the market means that it is becoming more important to seek to establish common definitions between jurisdictions, in particular with regard to what is meant by the works 'fake' or 'authentic', and to provide disappointed buyers with appropriate remedies before the courts of each country. This would include not only a modification of the law of contract, but also a reconsideration of the adequacy in this area of existing periods of limitation.

AVANT-PROPOS

Dans cette étude de droit comparé, l'auteur étudie le problème des faux sur le marché de l'art en abordant quatre questions particulières. Premièrement, l'existence et l'étendue du devoir précontractuel du vendeur de renseigner le potentiel acheteur quant à l'authenticité de l'œuvre dont il envisage l'acquisition. Deuxièmement, les conditions auxquelles on peut admettre qu'une garantie d'authenticité ait été fournie, ainsi que la nature juridique d'une telle garantie. Troisièmement, les moyens à la disposition de l'acheteur dans l'hypothèse où l'œuvre qu'il croyait authentique s'avère être un faux. Ceci recouvre les moyens relatifs à la formation de la volonté (notamment l'invalidation du contrat pour dol ou erreur, respectivement « *misrepresentation* »), de même que ceux relatifs à l'exécution du contrat (garantie du vendeur pour les défauts de la chose vendue ou autre fondement de responsabilité contractuelle). Enfin, la question particulière de la prescription, qui constitue souvent en pratique l'obstacle principal à une action de l'acheteur, est analysée.

Après avoir exposé l'état de la jurisprudence et de la doctrine en droit suisse, droit français et droit anglais, les diverses solutions sont comparées, puis évaluées avec les besoins du marché de l'art pour chacun des quatre aspects précités. Certaines divergences fondamentales d'approche entre les systèmes suisse et français, d'une part, et le système anglais, d'autre part, sont relevées.

L'auteur conclut qu'en vue d'assurer une protection efficace de l'acheteur, il serait opportun d'adopter une législation particulière en matière de vente d'œuvres d'art, lesquelles ne sauraient, vu les caractéristiques du marché, être assimilées à d'autres objets mobiliers.

Une telle législation instaurerait une obligation de renseignement à la charge du vendeur dans l'hypothèse où les parties au contrat ne seraient pas sur un pied d'égalité et lorsque des informations en matière d'authenticité ne seraient pas aisément accessibles.

De plus, les conditions d'une garantie d'authenticité, soit l'allocation du risque d'un faux, seraient définies. Un critère essentiel à prendre en compte à cet égard serait l'acceptation éventuelle d'un aléa, au moment de la conclusion du contrat, quant à l'authenticité. Le décret français du 3 mars 1981 sur la répression des fraudes en matière de transactions d'œuvres d'art et d'objets de collection apporte de la lumière sur la terminologie empruntée. Par ailleurs, l'importance à attribuer à des éléments tels que le prix payé ou la réputation d'un marchand serait définie.

"Counterfeits ... are a persistent pathology of the art world. Counterfeiters make real trouble and do real harm. In a phrase, they vandalize the human record."

(John Henry Merryman, 'Counterfeit and Artists' Right' in François Dessemontet and Raphaël Gani (eds), *Creative Ideas for Intellectual Property: The ATRIP Papers 2000-2001*, (2002, Lausanne), pp. 294-316, at pp. 294-295.)

CHAPTER 1

INTRODUCTION

Fakes have existed for centuries, but "[their] influx into the marketplace has reached epidemic proportions".[1] They have been found in well-known collections, galleries and museums around the world. They represent up to 40% of all art transactions.[2] The general interest in art has increased considerably over the past few decades. Demand has risen, but the supply of works of art has remained relatively constant, thus increasing the value of art and creating an incentive for fraud. People are ready to spend fortunes; for example, Raphael's *Madonna of the Pinks* (1507-8) was bought by the National Gallery for £22 million in April 2004. Forgeries are most likely to be made of prestigious works by famous artists. Therefore, the price paid by a person who purchases a fake assuming it to be an original may be extremely high.

This book focuses on the contractual relationship between the buyer and the seller of a work of art. It is assumed that the buyer is willing to purchase an authentic work, which later turns out to be a forgery.

I. DEFINITIONS

A *fake* is a non-authentic work of art. It may be defined as a work of art made or altered, with intent to deceive, in a manner that it appears to have an authorship, origin, date, age, period, culture or source which it does not in fact

1 Leonard D. DuBoff, Christy O. King and Sally Holt-Caplan, 'Authentification', Booklet K in *The Deskbook of Art Law*, (2nd edn, 1999, New York), p. K-3.

2 See DuBoff *et al.*, *op. cit.* note 1, p. K-3; John Henry Merryman, 'Counterfeit Art' (1992) 1 *International Journal of Cultural Property*, pp. 27-77, at p. 43; Guislaine Guillotreau, *Art et crime – La criminalité du monde artistique, sa répression*, (1999, Paris), p. 98.

possess.[3] The words fake, forgery and counterfeit are used as synonyms in this book.

The expression *guarantee of authenticity* is to be understood as any assurance with legal effects, given by the seller or implied by the law, that the sold work of art is not a forgery.

The terminology used on the art market, especially in auction catalogues, can be somewhat confusing to the uninitiated. If a work is stated to be 'by Picasso', it is to be held that it is an authentic work by Picasso. This is to be distinguished from the following expressions:

* 'Attributed to' (probably by Picasso);
* 'Studio of' (by another artist, with or without Picasso's help);
* 'Circle of' (by someone closely associated with Picasso);
* 'Style of' (by a contemporary painter of Picasso working in his style);
* 'After' (a copy of a known work by Picasso).[4]

A French decree of 3rd March 1981 provides definitions of such expressions.[5]

II. SPECIFICITIES OF THE ART MARKET

The art market presents six main characteristics, which underlie the legal issues studied in this book:

* *Uniqueness of objects*: The art market relates to works of art, whose main characteristic is to be unique individualised objects.[6]

3 See for example, Sotheby's definition of 'counterfeit' in its Authenticity Guarantee (Appendix II, below, page 71); Christie's Conditions of Sale (Appendix III, below, page 74), art. 6; Michigan Warranty in Fine Arts Statute reproduced in Franklin Feldman, Stephen E. Weil and Susan Duke Biederman, *Art Law – Rights and Liabilities of Creators and Collectors*, volume II, (1986, Boston/Toronto), pp. 120-121.

4 Alice Beckett, *Fakes: Forgery and the Art World*, (1996, London), p. 42.

5 *Décret 81-255 sur la répression des fraudes en matière de transactions d'œuvres d'art et d'objets de collection* (Appendix VI, below, page 89). Similar definitions have been adopted in the New York Arts and Cultural Affairs Law, § 13.01(3), available on: http://home.att.net/~allanmcnyc/art_laws.html#fn0 (accessed on 30 June 2005).

6 An exception may be found in works made in a few examples, such as prints, lithographs, sculptures from the same cast.

- *Subjective price-making*: The value of works of art depends to a great extent on subjective and psychological elements, some of which relate to the intrinsic qualities of the object itself, especially authenticity, while others are external to it. Doubts as to authenticity act as a severe depressant on the value of the object. Higher certainty about the work of art is reflected in higher purchase prices.[7]

- *Uncertainty about authenticity*: A work of art work is generally authenticated, i.e. established to be genuine, by documentation (e.g., sales records, correspondence, exhibition and auction catalogues, the artist's archives), stylistic enquiry (examination of the work by an expert and subjective determination of its authenticity on the basis of his knowledge, experience and intuition), and scientific analysis (objective procedures, such as radiocarbon age determination, thermo-luminescent analysis, x-ray photography).

 However, it remains a very difficult and expensive task to detect forgeries: the documentation of fakes is sometimes also forged, and neither scientific testing nor stylistic analysis are totally reliable. Absolute certainty about authenticity can never be reached. A work of art which was held to be authentic may suddenly, in particular with the development of new technical methods, be discovered to be a fake. Moreover, the results of a stylistic enquiry may vary from expert to expert, and the same expert may change views over time. Thus, some people contend that buying a work of art is often making a bet.[8]

- *Time lapse*: Works of art are long – if not forever – lasting objects. Authenticity does not vary over time: a work of art is authentic or not from the date of its creation.[9] However, problems of authenticity are most likely to appear many years after the purchase. New scientific

7 Bruno S. Frey, *Arts & Economics: Analysis & Cultural Policy*, (2nd edn, 2003, Berlin/Heidelberg/New York), p. 206.

8 Yann Gaillard, *Marché de l'Art: les chances de la France*, Information Report 330 (1998-1999), Commission of Finances, available on: http://www.senat.fr/rap/r98-330/r98-330.html (accessed on 30 June 2005), § II. c. 3.

9 The problem of restoration is not considered here.

techniques may have been discovered or experts' opinions may have evolved during this time lapse.

- *Multiplicity of actors with different knowledge*: Many actors, from various backgrounds and with an uneven knowledge about art, may intervene: habitual or irregular private collectors, galleries, auctioneers, museums, etc. As a result, the contracting parties are frequently on an unequal footing.

- *High risk of fraud*: The sheer number of inauthentic works of art in the marketplace, the difficulty and time needed to detect them, as well as the diverging levels of knowledge of the parties, are factors enabling a seller to fraudulently make the buyer believe that he is acquiring an authentic work.

III. SCOPE, STRUCTURE AND METHOD

A. SCOPE AND LIMITS OF THE BOOK

Many legal issues arise in the context of forgeries, for instance:

- the criminal prosecution of forgers and those who knowingly pass counterfeits, as well as the seizure and destruction of such works;
- intellectual property rights, in particular copyright, and moral rights of the artist;
- the duties and liability of experts authenticating works of art;
- private international law issues.[10]

This book focuses on the four following subjects arising from the (pre-)contractual relationship between the buyer and the seller:

- the seller's *pre-contractual duty to disclose information* to the potential buyer regarding the authenticity of the contemplated work of art;
- the conditions under which a *guarantee of authenticity* of the sold work may be considered as having been provided and the nature of such a guarantee;

10 Regarding issues of jurisdiction and applicable law, see e.g. Marc Weber, 'Der internationale Kauf gefälschter Kunstwerke', *PJA/AJP* 2004, p. 947 *et seq.*

- the *remedies* available to the defrauded buyer, both at the levels of the formation of the contract (i.e. when he claims that his consent has been vitiated) and the performance of the contract (i.e. when he claims that the contract was breached or not exactly performed); and

- the specific question of the *limitation periods* governing the remedies.

These practical problems arise chronologically, from the relationship between the parties prior to the conclusion of the contract to the legal recourse of the buyer against the seller when the work of art turns out to be a forgery.

The situation where the person mistaken as to authenticity is the seller, is considered only to the extent that general principles may be extracted.[11] This paper assumes that the sale is voluntary.[12] No distinction is made according to whether the sale is private or public;[13] it should however be noted that auctioneers sometimes undertake responsibility for questions of authenticity[14] and therefore do not act only as the seller's agent.[15] Finally, an important hypothesis is that the seller's liability has not been validly excluded or limited: this book focuses on the legal framework as such and not on the modifications of it made by the parties through clauses excluding or limiting the seller's liability.

The three following jurisdictions are examined: Switzerland, France and England.[16] The same problems are likely to occur in each of them.

11 Many French cases deal with the situation of the defrauded seller (e.g., the *Poussin* and *Fragonard* cases, noted below in chapter 3, notes 23, 41 and 33).

12 As opposed to forced sales (for instance in case of bankruptcy); differences would lie, for instance, in the existence and extent of a guarantee.

13 Special rules governing auctions may exist, but will be disregarded for the purpose of this study.

14 Sotheby's and Christie's warrant the authenticity for a period of five years (Appendices II and III, below, pp. 71 and 74).

15 For instance, Christie's was held to have contracted both as agent and as principal and to be liable for the sale of a forgery (*De Balkany v. Christie Manson and Woods Ltd* [1997] Tr. L.R. 163, noted by Norman Palmer in (1996) I *Art Antiquity and Law* pp. 49-58.

16 The United Nations Convention on Contracts for the International Sale of Goods of 11 April 1980, ratified by Switzerland and France, is not dealt with here.

B. STRUCTURE AND METHOD

This book examines the Swiss, French and English legal systems (*infra*, chapters 2-4). Then, in a comparative section, the various solutions with respect to each of the issues identified above are summarised and compared, as well as evaluated with the needs of the art market (*infra*, chapter 5).

One specific question is whether the solutions provided by the legal systems examined are tailored to the specificities of the art market or whether a specific regime for the sale of works of art would be more appropriate. In the latter case, a list of factors to be considered should be drafted.

The method adopted, though it deals in its conclusion with suggestions about potential new legislation to be adopted, remains essentially functional.

The sources which have been used include statutes, case-law, case comments and legal articles in each jurisdiction. In order to obtain a more accurate picture of the functioning of the market, research about problems of authenticity has also been made in the practices of the art market (such as articles of incorporation of art dealers' associations[16] or auctioneers' business conditions), as well as in documents relating to other jurisdictions. In contrast to England, many cases involving forgeries have been reported in France and such issues are frequently discussed in the *doctrine*. Swiss law stands half way. The description of each legal system is essentially based on sources dealing directly with problems of authenticity. Little analogy has been drawn from other matters.

16 E.g., *Code d'éthique du Syndicat Suisse des Antiquaires et Commerçants d'Art* of 27 May 2000.

Chapter 2

Swiss Law

I. The Seller's Duty to Inform

A duty to inform may be deduced from the rules of good faith; it has been recognised in art transactions.[1] Its existence and extent depend mainly on the disparity of knowledge between the parties and the access to information. Such a duty should be denied if the seller is a layman and the buyer a specialist, or if the facts are easy to check or should be known by the buyer.[2] Conversely, if a technical or specific knowledge which confers an advantage to one party is needed, a duty to inform will be admitted. The same applies if only one party is assisted by a specialist.[3] The practical difficulties in detecting forgeries are impediments in the search for the truth as to authenticity. The seller's duty to disclose facts to the buyer in this respect is therefore quite likely to be recognised by the courts.

If the seller is aware that the buyer is mistaken as to authenticity and that this would have a direct influence on the conclusion of contract, he must provide him with information,[4] even if the mistake is due to the buyer's negligence.[5]

1 Bruno Schmidlin in Luc Thévenoz and Franz Werro (eds), *Commentaire romand, Code des obligations I*, (2003, Geneva/Basle/Munich), ad art. 23/24 CO, n. 56; see also Hans-Peter Katz, *Sachmängel beim Kauf von Kunstgegenständen und Antiquitäten*, (1973, Zurich), pp. 123-130.

2 See *Sem. Jud.* 1961 pp. 127-128; *ATF* 92 II 328, *JdT* 1968 I 34, s. 3b; Max Baumann, David Dürr, Viktor Lieber and Arnold Marti, *Schweizerisches Zivilgesetzbuch, volume I/1, Finleitung art. 1-7 ZGB*, (1998, Zurich), ad art. 2 of the Swiss Civil Code, n. 174; Bruno Schmidlin, *Das Obligationenrecht, volume VI/2/Ib, Mängel des Vertragsabschlusses*, (1995, Berne), ad art. 28 CO, n. 36.

3 Luc Thévenoz, 'La responsabilité de l'expert en objets d'art selon le droit suisse' in Quentin Byrne-Sutton and Marc-André Renold (eds), *L'expertise dans la vente d'objets d'art – Aspects juridiques et pratiques*, Zurich 1992, pp. 37-65, at p. 63; see also Ingeborg Schwenzer, *Schweizerisches Obligationenrecht, Allgemeiner Teil*, (1998, Berne), n. 38.06.

4 See *ATF* 116 II 431, *JdT* 1991 I 45, s. 3a.

5 Schmidlin, *op. cit.* note 1, ad art. 28 CO, n. 9.

Breach of the duty to inform is characterised as a *culpa in contrahendo*, giving the aggrieved party a claim for damages. If it can be proved that the seller intended to deceive, the contract is void for *dol* and damages are available.

II. THE GUARANTEE OF AUTHENTICITY

A. EXPRESS GUARANTEE

In practice, an express guarantee of authenticity is frequently found in certificates by experts or the artist, given by the seller to the buyer, or on the seller's invoices.

A guarantee of authenticity is an assurance given in the contracts of sale; it is not an independent contract giving rise to an independent contractual obligation of the seller.[6] An independent guarantee relates to future results and goes beyond the sole conformity of the object with the contract;[7] this is obviously not the case for authenticity, which does not vary over time.

B. TACIT GUARANTEE

In auctions of works of art, it has been held that the mere description of an object in the catalogue was not sufficient to be considered as a guarantee of authenticity.[8] However, a tacit guarantee, having the same effects as an express guarantee, may result from a price corresponding to the value of an authentic object.[9]

6 Sylvio Venturi in Thévenoz and Werro, *op. cit.* note 1, *ad* art. 197 CO, n. 19; Heinrich Honsell in Heinrich Honsell, Nedim Peter Vogt and Wolfgang Wiegand (eds), *Basler Kommentar zum schweizerischen Privatrecht, Obligationenrecht I*, (3rd edn, 2003, Basle/Geneva/Munich), *ad* art. 97 CO, n. 17; Pierre Tercier, *Les contrats spéciaux*, (3rd edn, 2003, Zurich), n. 660.
7 *ATF 126 III 426, JdT 1998 I 171*, s. 4.
8 *ATF 123 III 165, JdT 1998 I 2*, s. 4.
9 *ATF 102 II 97*, s. 2a (1881 Stamp '*Helvetia Assise*'); *RJJ* 1995/1996 p. 141, s. 3a-cc; Katz, *op. cit.* note 1, p. 47 *et seq.*; H. Becker, *Kommentar zum Zivilgesetzbuch, volume VI/2, Obligationenrecht, Die einzelne Vertragsverhältnisse, art. 184-551*, (2nd edn, 1941, Berne), *ad* art. 197 CO, nn. 12 and 14; Honsell, *op. cit.* note 6, *ad* art. 197 CO, n. 8; Tercier, *op. cit.* note 6, n. 663.

III. The Remedies of the Buyer (Including the Problem of Limitation Periods)

Swiss courts have allowed the defrauded purchaser to nullify transactions involving forgeries by availing himself of a fundamental mistake ('*erreur essentielle*') or deception ('*dol*') and, alternatively,[10] to invoke the seller's liability against defects of the sold object.

A. Remedies Regarding the Formation of the Contract

a) Erreur Essentielle

Article 23 of the Code of Obligations ('CO') states that a person acting under a fundamental mistake, at the time the contract is concluded, is not bound by it.

i) *Notion and Conditions*

Mistake may be defined as a vitiated formation of the contractual consent, consisting in a disparity between the false and the correct understanding of the reality.[11] If a party mistakenly believes that the work of art he is purchasing is authentic when it is not, there is a mistake.

Only fundamental mistakes are operative. A mistake as to the authenticity of works of art is generally considered to relate to the qualities, and not to the identity of the subject-matter of the contract.[12] It is therefore not an *erreur essentielle* under article 24(1)(2). However, it may be one under article 24(1)(4), if it:

10 The buyer may elect the means he wishes to rely on. Even if the mistake relates to a defect of the object sold, the buyer is not bound by the strict sales provisions (*ATF* 114 II 131, below, note 14); this is criticised by many academics. Once the buyer invokes the sales provisions against defects, he will no longer be able to avoid the contract for mistake or *dol*, as it will be assumed that he has affirmed the contract (*ATF* 127 III 83, *Sem. Jud.* 2001 I 301). Conversely, if he avoids the contract, he will not be able to use the sales provisions against defects. See Peter Gauch, 'Sachgewährleistung und Willensmängel beim Kauf einer mangelhafter Sache – Alternativität der Rechtsbehelf und Genehmigung des Vertrages' *Recht* 2001, pp. 184-190; Ernst A. Kramer, 'Bemerkungen zu BGE 127 III 83ff.' *PJA/AJP* 2001, pp. 1454-1456.
11 Schmidlin, *op. cit.* note 1, *ad* art. 23/24 CO, n. 1.
12 *ATF* 126 III 59 (vase by Gallé), s. 3; *ATF* 52 II 143 (146) (Chah Abbaz Persian carpet); Schmidlin, *op. cit.* note 1, *ad* art. 23/24 CO, n. 26; Ingeborg Schwenzer in Honsell *et al.*, *op. cit.* note 6, *ad* art. 24, n. 12.

relates to facts which, pursuant to the rules of good faith in the course of business, could be considered by the mistaken party as a necessary basis of the contract ('*erreur de base*').

The facts must be paramount, both subjectively (the party would not have concluded the contract, or not on the same terms [e.g., at the same price], had he not been mistaken) and objectively (the mistake relates to elements considered by the rules of commercial loyalty as being necessary in the trade).

Mistakes as to the authenticity of works of art or collectors' items are used as typical illustrations of the *erreur de base*. Important court decisions involve such mistakes;[13] it was specified that they also relate to the false appreciation of the value of the object.

In the *van Gogh* case, the claimant bought a painting, which had belonged to a well-known banker and was considered to be an authentic van Gogh. Four years later, he learnt from a connoisseur that it was a fake. The Supreme Court held that:

> The authenticity of the painting which was admitted by both parties, at the time the contract was concluded, was a circumstance which objectively, in the perspective of loyalty in business, seemed paramount, so that a mistake on this issue could not be considered as a simple mistake as to the motives without any legal consequences. It was clear that the claimant would not have bought the painting and would not have paid the requested price had he not been persuaded of its authenticity.[14]

13 See in particular the decisions of the Swiss Supreme Court in cases involving: a painting by van Gogh (below, note 14), a drawing by Picasso (below, note 15), a Chah Abbaz Persian carpet (above, note 12), a collectors' stamp of 1881 (above, note 9) and a vase by Gallé (above, note 12). See also cantonal decisions: Zurich High Court: *ZR* 59/1960 n. 122 (violin by Gagliano), *ZR* 62/1963 n. 35 (painting *Danseuses* by Degas), *ZR* 66/1967 n. 106 (painting by Vautier, below, note 18), *ZR* 68/1969 n. 1 (painting *La Liseuse* by Degas, below, note 18); Berne High Court: *RJB* 1965 pp. 145-148 (painting by Albert Anker); Basle High Court: *RSJ/SJZ* 27/1930-31 pp. 221-222, n. 39 (commode Louis XVI); Geneva High Court: *RSJ/SJZ* 37/1940-41 p. 233, n. 156 (furniture Louis XV); Jura High Court: *RJJ* 5-6/1995-1996 pp. 141-149 (restoration of a clock).

14 *ATF* 82 II 411, *JdT* 1957 I 182 (painting by van Gogh), s. 7 (free translation).

In the *Picasso* case, involving the forgery of a drawing signed 'Picasso' and guaranteed by the seller in writing to be authentic, the Supreme Court confirmed this view. It added that the authenticity is especially important if the artist is well-known, since it influences the value of the work.[15]

Since the objective importance of authenticity is assumed, the purchaser of a forgery must only prove that the following three conditions have been met:[16]

* *He had no knowledge that the object being sold was a fake.* If the buyer should have known that the object being sold was a fake, he may not avail himself of his mistake.[17] All the particular circumstances must be taken into account, as well as the buyer's degree of specialisation in the relevant art market.

 The Zurich High Court held that it could not be inferred from a low purchase price (30,000 instead of 500,000 Swiss francs for the picture *La Liseuse* by Degas) that the buyer should have realised that a work of art was not authentic.[18]

 A buyer cannot be penalised for having failed to seek the advice of an expert before acquiring the object, unless he had serious doubts as to its authenticity.[19]

* *The authentic nature of the object was a decisive element for the buyer when entering into the contract.* This is the requirement of the subjective importance of the mistaken facts.

* *The seller should have realised that the authenticity of the object was a decisive element for the sale.* However, the seller need not be mistaken himself, nor need he know of the buyer's mistake.

15 *ATF* 114 II 131, *JdT* 1988 I 508 (drawing by Picasso), s. 2a.

16 *ATF* 52 II 143 (146). This case involved the authenticity of a Persian carpet (above, note 12), but the same requirements apply to works of art.

17 Bernard Dutoit, 'La responsabilité du vendeur dans le commerce de l'art en droit privé suisse et à la lumière du droit comparé' in Martine Briat (ed.), *International Sales of Works of Art*, (1985, Geneva), pp. 83-101, at p. 85.

18 *ZR* 68/1969 n. 1 (above, note 13), s. 4; see also *ZR* 66/1967 n. 106 (above, note 13), s. d and Katz, *op. cit.* note 1, pp. 33-34.

19 See *Sem. Jud.* 1956 p. 272.

ii) Consequences

1. Right of the mistaken buyer to nullify the contract

The buyer may nullify the contract within one year from the discovery of his mistake, by notifying the seller of his intention not to maintain the contract (article 31). The intervention of the courts is not necessary. If the mistaken party does not make the declaration within this period, the contract is fully valid and binding upon both parties.

The one-year limitation period starts to run from the date on which the buyer is certain about his mistake, not from the date when he has doubts about it.[20]

In the *Picasso* case, the drawing was discovered to be a forgery eleven years after its purchase. The Supreme Court, expressly acknowledging that the buyer needs protection,[21] ruled that there was no absolute limitation period for nullifying a contract for mistake, provided the mistaken party has acted in good faith (see article 25). The claimant, who made the declaration within one year from the discovery of his mistake, could therefore validly nullify the contract eleven years after its conclusion.[22] This decision has been criticised by many academics, who argue that an absolute limitation period of ten years[23] starting to run from the date of the conclusion of the contract should apply, especially where the contract has been performed by the parties.[24] They contend that it would be unsound and contrary to the security of transactions if a party were able to nullify a contract for an unlimited period of time.

2. Restitution

Once the contract has been nullified, the seller has a proprietary claim for the return of the object, whereas the

20 *ATF* 82 II 411 (above, note 14), s. 8a; Schwenzer, *op. cit.* note 12, *ad* art. 31 CO, n. 12.

21 *ATF* 114 II 131 (above, note 15), s. 1c.

22 *Ibid.*, s. 2b-2c.

23 In some cases a limitation period of five years is suggested (Wolfgang Wiegand, 'Bemerkungen zum Picasso-Entscheid' *Recht* 1989, pp. 101-111, at p. 108).

24 Peter Gauch, 'Picasso-Entscheid Kommentar' *SAS* 61/1989, pp. 152-160, at pp. 155-156; Heinrich Honsell, *Schweizerisches Obligationenrecht, Besonderer Teil*, (7th edn, 2003, Berne), p. 115; Wiegand, *op. cit.* note 23, pp. 107-108; Schwenzer, *op. cit.* note 12, *ad* art. 31 CO, n. 14; Schwenzer, *op. cit.* note 3, n. 39.16; Pierre Engel, *Traité des obligations en droit suisse*, (2nd edn, 1997, Berne), pp. 340-341.

buyer has a claim for the reimbursement of the price paid pursuant to the unjust enrichment provisions (article 62 *et seq.*).[25]

The unjust enrichment claim is barred one year after the prejudiced party knew of the existence of his claim,[26] but in any event ten years after the claim arose (article 67(1)).

In the *Picasso* case, the Supreme Court held that the starting point of the ten-year limitation period to commence proceedings for unjust enrichment was the date of performance (i.e. the date on which the price was paid) rather than the date of the declaration of nullity. Therefore, in that case, the ten-year limitation period had already lapsed by the time the claimant made the declaration of nullity.[27]

Thus, although the claimant was entitled to nullify the contract for *erreur essentielle* eleven years after its conclusion, he was time-barred from obtaining the reimbursement of the purchase price. What is the point of allowing the nullity, if the price paid cannot be recovered? Many academics denounce the paradox of the situation: the unjust enrichment claim could be time-barred before it has even arisen. They argue that the ten-year limitation period laid down by article 67 should start to run only from the date of the declaration of nullity.[28]

25 *ATF* 129 III 320, *Sem. Jud.* 2004 I 33, s. 7.1.1.
26 *ATF* 129 III 503, *Sem. Jud.* 2004 I 278, s. 3.4. A faulty ignorance is not assimilated to knowledge (*ATF* 109 II 433, *JdT* 1984 I 314). The limitation period does not start running with the simple knowledge that a specialist has doubts about the authenticity, but only when an expert has given a definite opinion (*RJB* 1965 pp. 145-148).
27 *ATF* 114 II 131 (above, note 15), s. 3b-3c.
28 E.g., Schwenzer, *op. cit.* note 12, *ad* art. 24 CO, n. 10; Schwenzer, *op. cit.* note 3, n. 39.27; Bruno Huwiler in Honsell *et al.*, *op. cit.* note 6, *ad* art. 67, n. 5; Schmidlin, *op. cit.* note 1, *ad* art. 31 CO, nn. 9-10; Schmidlin, *op. cit.* note 2, *ad* art. 23/24 CO, nn. 138-146, *ad* art. 31, n. 95 and n. 133; Paul Piotet, 'A propos de l'arrêt "Picasso"' *JdT* 1988 CO I 519-523, at p. 523; Wiegand, *op. cit.* note 23, pp. 109-111. For a different reasoning: see Gilles Petitpierre in Thévenoz and Werro, *op. cit.* note 1, *ad* art. 67 CO, n. 8.
 Some authors defend the position of the Supreme Court: e.g., Gauch, *op. cit.* note 24, pp. 157-160; Hans Merz, 'Irrtum und Gewährleistung (Das Picasso-Urteil)' *RJB* 126/1990, pp. 255-259, at p. 259; Engel, *op. cit.* note 24, p. 340. In parallel, these authors also defend the idea that the right to nullify the contract should be subject to a ten-year absolute limitation period; see references above, note 24.

3. Damages

A mistaken party who nullifies the contract may not claim damages,[29] even where the mistake has been involuntarily induced by the seller.[30] This is a serious disadvantage for the defrauded buyer of a forgery, who may have incurred considerable damage. The buyer could however rely on a breach of the seller's duty to inform in order to claim damages (*culpa in contrahendo*),[31] although this route has apparently not been used in this context to date. The claim would be subject to the dual limitation period of article 60: one year from the date of the knowledge of the damage, but a maximum of ten years from its occurrence (in this case, the date of the contract).

If the buyer's mistake is attributable to his own negligence, he might have to compensate the seller for any damage resulting from the nullity of the contract, unless the seller knew or should have known of such mistake (article 26). Compensation is excluded in particular if the seller was also mistaken about the lack of authenticity, or if he would also have renounced to make further enquiries.[32]

b) Dol

Article 28(1) states that if a party has been induced to enter into a contract by the other party's *dol*, the contract shall not bind the deceived party even if the mistake so induced was not fundamental.

In practice, article 28 has only rarely been used in cases involving fakes because of the difficulty of proving the seller's intention to deceive.

i) Notion and Conditions

There is *dol* when a party intentionally induces another into a mistake, or when he entertains or confirms a pre-existing

29 *ATF* 82 II 411 (above, note 14), s. 6c.
30 In such a case, however, some authors consider that the compensation of the mistaken party's damage should not be excluded (Engel, *op. cit.* note 24, p. 347).
31 For further details, see Baumann *et al.*, *op. cit.* note 2, *ad* art. 2 of the Swiss Civil Code, nn. 181-191.
32 Schmidlin, *op. cit.* note 1, *ad* art. 26 CO, n. 4.

mistake, in order to conclude a contract.[33] This applies to the seller of a forgery in the following circumstances:

- The buyer mistakenly believes that the work of art is authentic;

- His belief was induced by the seller's deceptive behaviour;

- The seller knew that the work was not authentic (or was not sure that it was) and realised that the buyer ignored it or may have ignored it; and

- Without the deception, the buyer would not have entered the contract or not on the same terms (in particular at the same price).

Dol covers the situation where the seller breached his pre-contractual duty to inform by deceptively dissimulating the lack of authenticity or the existence of doubts.

ii) Consequences

1. Right of the deceived buyer to nullify the contract and restitution

Article 31(1)-(2) also deals with *dol*. Therefore, all developments above regarding the right of the prejudiced party to avoid the contract, as well as the effect of the nullity on the return of the object and the restitution of the price paid, apply *mutatis mutandis* to *dol*.

The solution of the Supreme Court in the *Picasso* case, imposing a ten-year limitation period from the date of payment, is even more arguable in the context of *dol*, where the fraudulent seller certainly does not deserve protection.

2. Damages

Dol is a tort, which creates a liability to indemnify (article 41).[34] Therefore, the deceived buyer may claim damages, even if he chooses not to nullify the contract (article 31(3)). The infringement of a pre-contractual duty to inform may also give rise to a claim for damages. However, the total

33 *ATF* 131 III 145, *Sem. Jud.* 2005 I 321, s. 8.1. Schmidlin, *op. cit.* note 1, *ad* art. 28 CO, pp. 179-182; Engel, *op. cit.* note 24, pp. 350-355; Schwenzer, *op. cit.* note 3, pp. 231-233.
34 *ATF* 61 II 228, *JdT* 1936 I 84, s. 2.

indemnification may not exceed the damage suffered by the deceived buyer. The limitation period in respect of a claim for damages is the dual one year/ten year period discussed above (article 60).

The fraudulent seller may not claim compensation.

B. REMEDIES REGARDING THE PERFORMANCE OF THE CONTRACT

If the forgery is considered to be a defective object (*peius*), the defrauded buyer may only rely on the specific means set forth in the special part of the Code of obligations related to sales contracts (article 197 *et seq.*). Conversely, if it is treated as an object different from the subject-matter of the contract (*aliud*), the general means of the law of obligations dealing with the non-performance of the contract (article 97 *et seq.*) apply.[35]

In the *van Gogh* and *Picasso* cases, the Supreme Court held that a forgery was a *peius* rather than an *aliud*.[36] This view is shared by some authors,[37] but criticised by others,[38] who consider that a fake cannot be assimilated to an

35 The distinction between *aliud* and *peius* corresponds to the distinction between a mistake as to the identity of the subject-matter of the contract and a mistake as to its qualities (Schwenzer, *op. cit.* note 12, *ad* art. 24, n. 13).

36 *ATF* 82 II 411 (above, note 14), s. 3b; *ATF* 114 II 131 (above, note 15), s. 1a.

37 Schmidlin, *op. cit.* note 2, *ad* art. 23/24 CO, n. 279; Hans Giger, *Das Obligationenrecht, volume 2/1/1, Der Fahrniskauf,* (1979, Berne), prelim. remarks to art. 197-210, n. 46; Pierre Engel, *Contrats de droit suisse,* (2nd edn, 2000, Berne), p. 35; Honsell, *op. cit.* note 6, *ad* art. 197 CO, n. 8; Heinrich Honsell, 'Sachmängel und Kunsthandel' in *Rechtskollisionen, Festschrift für Anton Heini,* Zurich 1995, pp. 213-223, at p. 213; Pierre Cavin, *La vente, l'échange, la donation,* in *Traité de droit privé suisse, volume VII/1,* (1978, Fribourg), p. 115; Guy Stanislas, *Le droit de résolution dans le contrat de vente,* (1979, Geneva), pp. 169-170; Katz, *op. cit.* note 1, pp. 30-31 and 95; Hans-Conrad Cramer, *Die Behandlung der Kunstfälschung im Privatrecht,* (1947, Zurich), p. 13; see also Michel Amaudruz, *La garantie des défauts de la chose vendue et la non-conformité de la chose vendue dans la loi uniforme sur la vente internationale des objets mobiliers corporels. Etude de droit comparé,* (1998, Lausanne), p. 44; Theodor Bühler, 'Zur sogenannten Alternative Gewährleistung-Irrtum im Kaufrecht' *RSJ/SJZ* 74/1978, pp. 1-8, at p. 6.

38 Olivier Weber-Caflisch, *Faux et... défauts dans la vente d'objets d'art, Etude juridique de la question de l'authenticité et de la garantie en raison des défauts de la chose,* Genève 1980, p. 53 *et seq.*; Dutoit, *op. cit.* note 17, pp. 87-88; H. Becker, *Kommentar zum Zivilgesetzbuch, volume VI/1, Obligationenrecht, Allgemeine Bestimmungen, Art. 1-183,* (2nd edn, 1941, Berne), *ad* art. 24 CO, n. 22; Becker, *op. cit.* note 9, preliminary remarks to arts 197-210, n. 4; Konrad Bloch, 'Zur Frage der Schlechtlieferung und Falschlieferung beim Kauf' *RSJ/SJZ* 53/1957, pp. 209-212, at p. 210.

authentic object with a defect, because there is a disparity in the nature and identity of the objects.

a) The Seller's Liability for Defects

i) Conditions

Under article 197(1), the seller is liable to the buyer for the promised qualities and for any defects, which materially or legally eliminate or substantially reduce the value of the object or its fitness for its intended purpose. The seller need not have known of these defects (article 197(2)).

The lack of authenticity of works of art has been treated as a defect in the sense of article 197, which is defined as the absence of a quality that had been promised by the seller or that the buyer could reasonably have expected.[39]

The buyer must have neither been aware of nor accepted the defect at the time of the sale (article 200).[40]

The buyer has to examine the condition of the object sold and notify the seller immediately of any defects (article 201). The time frame depends on the circumstances of the particular case: it may be from a few days to a few months.[41] In the art market, where inauthenticity is not easily detected, it is now likely to be considerably longer, since the limitation period has just been extended. The duty of examination will be greater for a buyer with specific qualifications than for an ordinary buyer.[42] A buyer who has serious doubts is required to seek the opinion of an expert.[43] However, if the seller has acted fraudulently, he may not argue that the buyer delayed in notifying the lack of authenticity (article 203).

Until recently, a greater impediment for the defrauded buyer was the short limitation period, which was of one

39 Tercier, *op. cit.* note 6, n. 636.
40 If the buyer should have known about the defects, the seller is generally not liable (Sylvio Venturi, *La réduction du prix de vente en cas de défaut ou de non-conformité de la chose, le Code suisse des obligations et la Convention des Nations Unies sur les contrats de vente internationale de marchandises,* (1994, Fribourg), p. 101, n. 433).
41 *ATF* 81 II 56, *JdT* 1955 I 562, s. 3b. The courts will be less strict for a private buyer than for a dealer (Venturi, *op. cit.* note 6, *ad* art. 201 CO, n. 10).
42 Venturi, *op. cit.* note 6, *ad* art. 201 CO, n. 7.
43 *Sem. Jud.* 1956 p. 272; Honsell, *op. cit.* note 6, *ad* art. 201 CO, n. 5; Cavin, *op. cit.* note 37, p. 89. See also *ATF* 131 III 145, *Sem. Jud.* 2005 I 321 (above, note 33), s. 6.3.

year following delivery to the buyer of the object sold, even if the defect was only discovered at a later date (article 210). There were two exceptions to this one-year limitation period. First, when the seller had fraudulently deceived the buyer, the limitation period was of ten years (article 210(3) and article 127).[44] Secondly, where the seller had promised to extend the guarantee for a longer period (article 210(1-*in fine*)), the limitation period was lengthened correspondingly,[45] but not in excess of ten years.[46]

In art transactions, there is no doubt that a short one-year limitation period was unsatisfactory. This is why, for many years, the Supreme Court interpreted broadly the seller's promise of an extended guarantee: where the authenticity of a work of art had been expressly guaranteed by the seller, the claim was not subject to a one-year, but to a ten-year limitation period.[47] Later, the Supreme Court modified its case-law and required proof that the seller intended to permit the buyer to commence proceedings after the expiration of the one-year period; this change of interpretation was decided by reference to the security of transactions and the need to treat differently good faith and bad faith sellers.[48] However, in order not to "benefit unilaterally the seller and sacrifice the interests of the buyer", the Supreme Court confirmed that the buyer could alternatively invoke the *erreur de base*.[49] In practice, the short one-year limitation period prevented the defrauded buyer, in most cases, from relying on the sales provisions. This was considered as unfair, the *erreur de base* being more difficult to prove.[50]

44 *ATF* 107 II 231, *JdT* 1982 I 71; Schmidlin, *op. cit.* note 2, *ad* art. 28 CO, nn. 137-138; Michael Lips, *Die Kaufrechtliche Garantie*, (2002, Zurich), p. 49.
45 Stanislas, *op. cit.* note 37, p. 163.
46 *ATF* 99 II 185, *JdT* 1994 I 46, s. 2a; Dutoit, *op. cit.* note 17, p. 91; Venturi, *op. cit.* note 6, *ad* art. 210 CO, n. 8. See also Pascal Pichonnaz, in Thévenoz and Werro, *op. cit.* note 1, *ad* art. 141 CO, n. 3.
47 *ATF* 56 II 424, *Sem. Jud.* 1931 p. 428 (painting by Léopold Robert), s. 4; application of this case in *ATF* 94 II 26, *JdT* 1969 I 322, s. 4c. Approval of this solution by Pierre Cavin, 'Considérations sur la garantie en raison des défauts de la chose vendue' *Sem. Jud.* 1969, pp. 329-345, at p. 343.
48 *ATF* 102 II 97 (above, note 9), s. 2b. Approval of this solution by Stanislas, *op. cit.* note 37, p. 163.
49 *ATF* 114 II 131 (above, note 15), s. 1c (free translation).
50 Cavin, *op. cit.* note 37, p. 105.

This problem appears to have been resolved since 1ˢᵗ June 2005, when a new paragraph of the Code of Obligations extending the absolute limitation period to thirty years for claims related to cultural property entered into force (article 210(1*bis*)). This amendment was introduced by the Swiss Act on the International Transfer of Cultural Property of 20ᵗʰ June 2003 ('CPTA'), which implemented the 1970 UNESCO Convention on the Means of Prohibiting and Preventing the Illicit Import, Export and Transfer of Ownership of Cultural Property recently ratified by Switzerland.

In order to be subject to article 210(1*bis*), the cultural object must meet two cumulative criteria set forth in article 2 CPTA:

* It must *belong to one of the categories* stated in article 1 of the 1970 UNESCO Convention. These categories are defined very broadly.[51] Works of art such as paintings, sculptures, engravings and prints are covered (article 1(g) of the Convention). There is no age requirement for works of art, as opposed to furniture and instruments (article 1(k) of the Convention *a contrario*); so contemporary art may also fall into the category.

* The object is *significant* for archaeology, prehistory, history, literature, art or science. The notion of 'significant' has not been specified yet. However, the Swiss Office of Culture has stated that an object may qualify as 'significant' for example if the cultural object is exhibited or worthy of exhibiting in a museum, if its loss would represent a loss to the cultural heritage, if the object is of special interest to the public, if it is relatively rare, or if it is discussed in the specialised literature.[52]

It can reasonably be assumed that works of art which have been forged are 'cultural property' under the CPTA and

51 See Patrick J. O'Keefe, *Commentary of the UNESCO 1970 Convention on Illicit Traffic*, (2000, Leicester), p. 34; Report of the Swiss Government of 21 November 2001 regarding the 1970 UNESCO Convention and the CPTA, *FF* 2002 p. 505 *et seq.*, at p. 542.

52 Swiss Office of Culture, 'Checklist "Cultural Property" pursuant to the Cultural Property Transfer Act', available on http://www.bak.admin.ch/arkgt/kgt/files/Checkliste_Kulturgut_e.pdf (accessed on 30 June 2005).

that the new article 210(1*bis*) governs the claim of the defrauded buyer.

Thus, unless he knew or should have known about the lack of authenticity, the buyer may issue his claim against the seller within thirty years from the date of the contract. However, in the event that the seller was in good faith, the buyer is also bound by a one-year limitation period, which runs as of the discovery that the work of art is a forgery (article 210(1*bis*)). If the seller acted fraudulently, article 210(3) prevents him from arguing that the one-year limitation period has lapsed. Therefore, the buyer's claim against the bad faith seller appears to be only subject to the absolute thirty-year limitation period regardless of when the buyer discovered the lack of authenticity (article 210(1*bis in fine*).[53]

ii) Consequences

The buyer may unilaterally rescind the contract with retrospective effect, if the defect is such that it may not reasonably be expected from him that he keeps it (article 205(1)-(2)). The lack of authenticity of a work of art would be sufficiently serious to justify rescission. In such a case, the buyer returns the forgery to the seller (article 208(1)), who repays him the purchase price plus interest (article 208(2)). The seller must also compensate the buyer for any damage directly caused by the delivery of the forgery (article 208(2); e.g., costs related to preserving the work of art, insurance costs, transport costs to return the object, an exchange rate loss, fees of a private expert[54] and perhaps even the loss of value of the rest of the art collection[55]). For any further damage (e.g., lost profits), the seller is only liable if a fault – which is presumed – is attributable to him (article 208(3)).[56] In art transactions, the seller will in most cases be able to prove quite easily that he had good reason to believe in the authenticity, for instance by producing experts' certificates.

53 Another view would be to consider that the buyer who discovers that the work is a forgery must file his claim against the fraudulent seller within ten years, as this is the ordinary limitation period under Swiss contract law (article 127) and any derogation to it should be interpreted restrictively.

54 *RJJ* 1995/1996 p. 141, s. 4.

55 Weber-Caflisch, *op. cit.* note 38, p. 84; Dutoit, *op. cit.* note 17, p. 89, footnote 18.

56 The extent of the damages is greater than for *dol* (Honsell, *op. cit.* note 24, p. 119).

Therefore, in practice, a buyer who has bought a work of art with a view to selling it for profit may have difficulty in recovering damages for his lost profits.

In the event that the purchaser wishes to keep the fake but at its correct value, he may claim an indemnity for the difference in value (article 205(1)), which may not exceed the purchase price (article 205(3)).[57] No direct damages may be awarded to the buyer, since the contract still exists; however, indirect damages resulting from a fault of the seller may be claimed.[58]

b) General Liability for Non-Performance?

Under article 97, a party is liable in respect of damage arising from the non-performance or the breach of a contract, unless he proves that no fault is attributable to him. In this action, a fault of the seller is required (but presumed), as opposed to his liability for defects, which is objective. Rescission of the contract may follow (articles 102 and 107-109). The limitation period is of ten years from the date of the contract (article 127).

If the general action is based on defects of the object sold, the strict provisions of contracts of sale, in particular the duty to notify of any defects and the general one-year limitation period have to be respected.[59]

This, however, would not apply to fakes, if they were considered as an *aliud* rather than a *peius*, as some authors suggest despite the clear contrary position of the Supreme Court.[60] Before the revision of article 210, this alternative view presented notable advantages: it provided a longer limitation period (in contrast to the seller's liability against defects) and the possibility of recovering damages without invoking a breach of the seller's duty to inform (as opposed to mistake). However, as a result of the legislative change described above, the defrauded buyer's position now seems to be better protected by the sales provisions.

57 On the methods of calculation: see for instance Weber-Caflisch, *op. cit.* note 38, pp. 85-86; Venturi, *op. cit.* note 6, *ad* art. 205 CO, n. 20.
58 Weber-Caflisch, *op. cit.* note 38, p. 86.
59 *ATF* 114 II 131 (above, note 15), s. 1a; *ATF* 107 II 419, *JdT* 1982 I 380, s. 1a.
60 See above, notes 36-38.

CHAPTER 3

FRENCH LAW

I. THE SELLER'S DUTY TO INFORM

A duty to inform may arise from an inequality in information between the parties: a party who knows, or should know, either because of his professional qualification or his physical possession of the object, a fact which he recognises to be of decisive importance for the other contracting party, must reveal that fact when the latter would have difficulty in finding it out for himself or when he can legitimately expect to be able to trust him.[1] The ignorance of the contracting party must be legitimate, since there is no "established right to passivity".[2]

A duty to inform may exist in art transactions in such circumstances. Nevertheless, the courts have been cautious not to extend this duty unduly.[3] Thus, for instance, it was denied in a case involving the purchase of 85 photographs by Baldus for a price that the buyer knew to be derisory but which he failed to reveal to the seller;[4] this strict position was essentially explained by the fact that the parties, non-dealers, were on the same footing.[5]

The breach of the duty to inform may justify an award of damages under article 1382 of the French Civil Code ('FCC').

1 Jacques Ghestin, 'Le droit interne français de la vente d'objets d'art et de collection' in Martine Briat (ed.), *International Sales of Works of Art*, (1990, Geneva), pp. 131-156, at p. 142.
2 Jacques Mestre, 'Obligations et contrats spéciaux' *RTD civ.* 1986 p. 339, at p. 341 (free translation); see CA-Paris, 15 November 1990, *D.* 1992 somm. p. 264.
3 For example, in the absence of a specific enquiry, the seller is not required to inform the buyer of all previous attempts of sale (CA-Versailles, 13 April 1983, *Gaz. Pal.* 1984 somm. p. 60).
4 Cass. 1ère civ., 3 May 2000 (photographs by Baldus), *JCP* 2001 G II 10510, note Jamin, Petites Affiches 2000 n. 134, note A.-M. L.
5 François Duret-Robert, *Ventes d'œuvres d'art*, (2001, Paris), pp. 91 and 212.

If the concealed information relates to a substantial quality and the party is mistaken about this quality, the sale may be nullified for mistake. Should the seller have acted fraudulently,[6] the buyer may invoke *dol* to obtain the nullity of the contract.

II. THE GUARANTEE OF AUTHENTICITY

A. EXPRESS GUARANTEE

The guarantee of authenticity is express when it derives from statements of the seller. Such statements can essentially be found in auction catalogues, or, when the sale is private, on guarantee certificates or invoices. The seller has an obligation to deliver to the buyer, upon his request, a document stating the specificities of the work of art as to its nature, composition, origin and age which had been communicated prior to the sale.[7]

The 1981 Decree defines the existence and extent of a guarantee of authenticity by reference to the expressions used to describe the authorship of a work of art or its date of production.[8]

There is a guarantee that the artist is the author, save express reservation as to the authenticity, where:[9]

- it is stated that the work of art bears the signature of the artist;[10]
- the word 'by' is followed by the name of the artist;
- the name of the artist follows the description of the work.[11]

The indication of a specific period or date provides the guarantee that the work was produced at that time.[12]

6 Where the buyer is a layman, the professional seller is usually deemed to have acted fraudulently.
7 Decree, art. 1.
8 However, according to some authors, the use of such formulae is not decisive (Bruno Petit, *Contrats et Obligations. Erreur*, Jurisclasseur civil, 2/1998, n. 32).
9 Decree, art. 3.
10 Cass. 1ère civ., 7 November 1995 (painting by Herbin), *Bull. civ.* 1995 I n. 401, *RTD civ.* 1997 p. 113, obs. Mestre, *JCP* 1995 E pan. 1438 p. 449.
11 Cass. 1ère civ., 3 April 2002 (painting by Monticelli), *Bull. civ.* 2002 I n. 111, *D.* 2002 inf. rap. p. 1470.
12 Decree, art. 2.

The description that a work is 'attributed to' a certain artist guarantees that the work was produced during the period of production of the artist and that there are serious chances that he might be the author. However, there is no guarantee that he is the author.[13]

The words 'studio of' exclude the likelihood that the master himself has made the work of art or that there exist serious presumptions as to his actual authorship; they guarantee, however, that the work was made in the studio of the master or under his supervision.[14]

The designation 'style of' excludes all guarantees as to authorship, period of performance or school.[15]

B. TACIT GUARANTEE

In certain limited circumstances, the buyer can legitimately believe in the existence of authenticity. French courts recognise that the following elements, especially if they are combined, may ground a tacit guarantee:

- a high purchase price;[16]
- the appearance of the object;[17]
- the fact that the seller presents himself as being an antique dealer.[18]

This last element should extend to instances where a work of art is sold by or through well-known art galleries or auctioneers.

13 Decree, art. 4. See also Cass. 1ère civ., 16 December 1964 (painting by Courbet), *Bull. civ.* 1964 I n. 575, *Journ. des C.-P.* 1965 p. 23, *D.* 1965 jur. p. 136, *Gaz. Pal.* 1965 1 p. 251.

14 Decree, art. 5; CA-Paris, 12 February 1954 (painting school of Botticelli), *D.* 1954 p. 337, *Gaz. Pal.* 1954 1 p. 281, *Journ. des C.-P.* 1954 p. 212; CA-Paris, 27 February 1998 (painting by Poussin), *D.* 1998 inf. rap. p. 93.

15 Decree, art. 5. See also TGI-Paris, 7 May 1975 (painting type of Marieschi), *Gaz. Pal.* 1975 2 748, *D.* 1976 p. 605, note Jeandidier.

16 Cass. 1ère civ., 26 May 1965 (painting by Monticelli), *Bull. civ.* 1965 I n. 347. However, this criterion is not decisive *per se*, especially if the price of works by the artist fluctuates (Cass. 1ère civ., 26 January 1972 (painting by Magnasco), *Bull. civ.* 1972 I n. 32, *D.* 1972 jur. p. 517, *JCP* 1972 G 17065, *RTD civ.* 1981 p. 395, obs. Chabas). Conversely, a low purchase price may be considered as a factor raising doubts as to authenticity (Cass. 1ère civ., 31 March 1987 (sculpture of Tang period), *Bull. civ.* 1987 I n. 115, *Journ. des C.-P.* 1987 p. 73, *RTD civ.* 1987 p. 743, obs. Mestre; CA-Paris, 27 February 1998, note 91).

17 CA-Rennes, 17 June 1929 (painting by Nattier), *Gaz. Pal.* 1929 2 p. 396.

18 *Ibid.*

Trigeaud goes further: he considers that any work of art sold by a professional should be deemed to be authentic, save where there is an express clause excluding such guarantee.[19]

III. THE REMEDIES OF THE BUYER (INCLUDING THE PROBLEM OF LIMITATION PERIODS)

The defrauded buyer may rely on remedies related to the formation or the performance of the contract. The cumulative application of mistake (or *dol*) and liability for defects is controversial.[20]

A. REMEDIES REGARDING THE FORMATION OF THE CONTRACT

The buyer of a forgery may question the validity of the contract by pleading that his consent was vitiated because it was given by mistake (*'erreur substantielle'*) or induced by the deception (*'dol'*) of the seller (articles 1108-1109).

a) Erreur Substantielle

With respect to the purchase of works of art, the ordinary route for the defrauded buyer is to invoke his *erreur substantielle*.

i) Notion and Conditions

Mistake presupposes a disparity between the intellectual perception made by a party about a substantial quality of

19 Jean-Marc Trigeaud, 'L'erreur de l'acheteur, l'authenticité du bien d'art, Etude critique' *RTD civ.* 1982 pp. 55-85, at p. 85.

20 See Duret-Robert, *op. cit.* note 5, pp. 149-151; Petit, *op. cit.* note 8, n. 88; Marc Weber, 'Der internationale Kauf gefälschter Kunstwerke', *PJA/AJP* 2004, p. 947 *et seq.*, at pp. 953-955; Véronique Tharreau, *L'authenticité des œuvres d'art de l'antiquité*, (2003, Paris), available on: http://www.avocats-publishing.com/secteur.php3?id_secteur=12 (accessed on 30 June 2005), part IV, s. II/II. When the products sold are affected by defects within the meaning of art. 1641, the sales provisions concerning hidden defects constitute the sole basis for the action (Cass. 1ère civ., 14 May 1996, *Bull. civ.* 1996 I n. 213, *JCP* 1996 N II n. 46 p. 1585, note Boulanger, *JCP* 1997 III 19 nn. 12/13 p. 135, note Radé, *D.* 1998, jur. p. 305, note Jault-Seseke and 19 October 2004, not published, but available on: http://www.legifrance.gouv.fr, appeal no 01-17228; *contra*: Cass. 3ème civ., 17 November 2004, not published, but available on: http://www.legifrance.gouv.fr, appeal no. 03-14958). However, it was also held that a claim based on the sales provisions did not exclude a claim for nullity based on *dol* (Cass. 1ère civ., 6 November 2002, *Bull. civ.* 2002 I n. 260).

the subject-matter of the contract, on one hand, and the reality, on the other hand.[21]

Mistake is a cause of nullity when it relates to the substance of the object which is the subject-matter of the contract (article 1110). The 'substance' of the object not only embodies its material composition (wood, metal, etc.), but also extends to substantial qualities upon which the parties have agreed.[22] Thus, in art transactions, the *erreur substantielle* also relates to the substantial qualities of authenticity and origin; this was recognised in the famous *Poussin* case.[23]

Mistake as to the economic value of the object sold is not a vitiating factor, unless it is the consequence of a mistake as to the substantial quality. The buyer who pays an excessive price for a work of art in the belief that it is authentic may seek the nullity of the contract on the basis of his *erreur substantielle*.[24]

To obtain the nullity of the contract, the party must prove that he was mistaken as to authenticity at the time he contracted. This may be divided into six cumulative requirements, some of which partially overlap:

• The authenticity was a substantial quality;

• The certainty of authenticity was integrated in the contract;

21 Jacques Ghestin, 'L'authenticité, l'erreur et le doute' in *Le droit privé français à la fin du XXe siècle, Etudes offertes à Pierre Catala*, (2001, Paris), pp. 457-468, at p. 457.

22 The substantial qualities may be defined according to an objective or a subjective approach; the latter is most frequently used nowadays, although the courts also refer to objective criteria, in particular with respect to the authenticity of works of art. For further details: see Duret-Robert, *op. cit.* note 5, pp. 154-157 and Petit, *op. cit.* note 8, nn. 4-7.

23 CA-Versailles, 7 January 1987 (painting *Olympos and Marsyas* by Poussin), known as the '*Poussin* case' (final decision), *D.* 1987 p. 485, note Aubert, *JCP* 1988 G II 21121, note Ghestin, *RTD civ.* 1987 p. 741, obs. Mestre. In this case, the sellers successfully sought the nullity of the sale of a picture described as follows: 'Carracci (School of), Bacchanale'. The Court of Appeal held that any possibility of attribution to Poussin had been excluded, as there had been no suggestion of a possible attribution of the work to this artist or even his studio, his style or his mannerisms and that Poussin had never belonged to the 'School of Carracci'. Therefore, it had been proved that when the sellers offered the painting for sale, they were convinced that it was not by the brush of Poussin but only that it should be attributed to the School of the Carracci.

24 See Petit, *op. cit.* note 8, nn. 62-63.

- Without this certainty, the mistaken party would not have contracted;

- The mistake as to authenticity was excusable;

- The work of art is not authentic or there are serious doubts as to its authenticity; and

- The purchased object can be returned to the seller in its original condition.

1. Authenticity was a substantial quality

Authenticity of works of art is a quality that is deemed to be sought by any contracting party; it is therefore *objectively* regarded as a substantial quality. This has been justified as follows:

> As soon as a work of art is no longer recognised as being authentic, it ceases to exist as a work of art and becomes a mere decorative object; when its authenticity, without being formally set aside, has become uncertain, this work of art is affected in its artistic essence, independently from any financial consequence.[25]

There is some disagreement amongst academics as to whether or not it is necessary for the mistaken party to prove that the authenticity was also *subjectively* a substantial quality.[26] Considering the evidential difficulties encountered by the use of the subjective approach, it has been suggested that a presumption should be adopted to the effect that authenticity is always a substantial quality.[27]

25 CA-Versailles, 13 April 1983 (above, note 3; free translation).
26 In favour of a subjective test: see Petit, *op. cit.* note 8, n. 26; Jean Châtelain, 'L'objet d'art, Objet de collection' in *Etudes offertes à Jacques Flour*, (1979, Paris), pp. 63-94, at pp. 68-71. In favour of an objective test: see Henri, Léon and Jean Mazeaud and François Chabas, *Leçons de droit civil, Les obligations, Théorie générale*, (9th edn, 1998, Paris), n. 166 and *Lectures* p. 176 *et seq.*
27 Jean Carbonnier, *Droit civil, volume 4, Les obligations*, (22nd edn, 2000, Paris), p. 110; Alain Bénabent, *Droit civil, Les obligations*, (7th edn, 1999, Paris), n. 78; Ghestin, *Traité de droit civil, Les obligations. La formation du contrat*, (3rd edn, 1993, Paris), n. 498; *contra*: Philippe Malaurie and Laurent Aynès, *Cours de droit civil, volume 2, Contrats et quasi-contrats*, (11th edn, 2001, Paris), n. 106.

In the case-law concerning forgeries, an objective appreciation, independent of the state of mind of the parties, seems to have been generally adopted.[28] In some cases, however, the courts have used a subjective approach and refused to nullify the contract because the buyer had failed to prove that he regarded authenticity as a substantial quality.[29] In our view, the subjective approach relates to the third condition, i.e. the problem of causation between the mistake and the conclusion of the contract.

The notion of 'substantial quality' has been extended to the possibility to establish authenticity with certainty,[30] because:

> with respect to its economic value, the slightest doubt as to the authenticity [of a work of art] has consequences similar to those arising from the lack of authenticity.[31]

2. Authenticity was integrated in the contract

The mistake must relate to a quality which has been either expressly or impliedly defined by the parties. Was authenticity integrated in the definition of the object sold as a matter of certainty? Or could the contract of sale be interpreted as presenting a risk in this regard? A claim for nullity will be rejected where the claimant was (or should have been) aware of a risk of forgery and accepted it, so that it became part of the agreement.[32] This is illustrated by the following excerpt from the *Fragonard* case:

28 Duret-Robert, *op. cit.* note 5, pp. 161-163; Mazeaud and Chabas, *op. cit.* note 26, n. 163. E.g., CA-Versailles, 7 January 1987, note 100; CA-Paris, 24 September 1987 (painting from Dutch and baroque period), *D.* 1987 inf. rap. p. 214; CA-Paris, 5 May 1989, *D.* 1989 inf. rap. p. 174; CA-Paris, 25 February 1994 (*SA Matignon Fine Art v. Benaim*), *D.* 1994 somm. p. 233, note Tournafond.

29 Cass. 1ère civ., 26 January 1972, note 93; Cass. com., 20 October 1970, *JCP* 1971 G II 16916, note Ghestin, *RTD civ.* 1971 p. 131, obs. Loussouarn, *Gaz. Pal.* 1971 1 p. 27.

30 Cass. 1ère civ., 26 February 1980 (sculpture of Tang period), *Bull. civ.* 1980 I n. 66, *Gaz. Pal.* 1980 2 somm. p. 374, *Défrénois* 1980 p. 384, obs. Aubert, *RTD civ.* 1981 p. 394, obs. Chabas; CA-Paris, 15 June 1981 (painting by Gauguin), *Gaz. Pal.* 1981 2 somm. p. 232; Cass. 1ère civ., 13 January 1998 (pastel by Cassat), *Bull. civ.* 1998 I n. 17 p. 11, *D.* 2000 jur. p. 54, note Laplanche.

31 TGI-Tarascon, 10 December 1999 (painting by Vlaminck), cited in Duret-Robert, *op. cit.* note 5, p. 181 footnote 5 and p. 173 footnote 7 (free translation).

32 Ghestin, *op. cit.* note 21, p. 461; Petit, *op. cit.* note 8, n. 28; see Cass. 1ère civ., 17 September 2003 (painting *La fuite en Egypte* by Poussin), *Bull. civ.* 2003 I n. 183.

> ... by selling or buying, in 1933, a work attributed to Fragonard, the parties accepted a risk as to the authenticity of the work ... [T]he risk as to the authenticity of the work was included in the contractual ambit; therefore, neither party could invoke a mistake in case of subsequent dissipation of the common uncertainty.[33]

In practice, the buyer must demonstrate that his mistake arose from statements of the seller (i.e. that there was an express guarantee of authenticity) or from the circumstances of the sale (i.e. that there was a tacit guarantee of authenticity). When appreciating the claimant's knowledge, the courts will take account of his experience in the field.[34]

3. Authenticity was decisive

The buyer must establish that he would not have contracted (or not on the same terms, e.g., at the same price), but for the mistake. His consent must have been vitiated by the erroneous belief, at the time of the conclusion of the contract, that the work was authentic.[35]

4. Excusable character of the mistake

To determine whether or not a mistake is excusable, the courts consider the ability of a party to inform himself (in particular by reference to his competence in the area), as well as the care he has taken to do so.[36] For example, a buyer's mistaken belief as to authenticity, despite the use of the expression "attributed to Courbet", was held to be inexcusable.[37] Generally, where the authenticity of a work

33 Cass. 1ère civ., 24 March 1987 (painting *Le Verrou* by Fragonard), known as the '*Fragonard* case', *Bull. civ.* 1987 I n. 105, *D.* 1987 jur. p. 489, note Aubert, *Journ. des C.-P.* 1989 p. 233, *RTD civ.* 1987 p. 743, obs. Mestre, *JCP* 1989 G II 21300, note Vieville-Miravette (free translation).
34 Cass. com., 20 October 1970 (above, note 29); Cass. 1ère civ., 31 March 1987 (above, note 16).
35 Cass. 1ère civ., 5 February 2002 (work by Spoerri), Bull. 2002 I n. 46, *JCP* 2002 G 2231 n. 50, *D.* 2003, chr. p. 436, note Edelman.
36 Duret-Robert, *op. cit.* note 5, pp. 172-173, n. 6.35. For instance, the courts refused to nullify the sale of a painting by Vlaminck which the buyer, a professional art gallery, had renounced to inspect before the purchase despite the high price of the work and the fact that it was unknown on the market (TGI-Tarascon, 10 December 1999, above, note 31). See also TGI-Paris, 31 January 2001 (statue of Sesostris III), cited in Duret-Robert, *op. cit.* note 5, p. 163 footnote 2.
37 Cass. 1ère civ., 16 December 1964 (above, note 13).

has been guaranteed, buyers (even professionals) will not be penalised if they fail, prior to sale, to seek a second opinion on the issue of authenticity.[38]

It is usually difficult to excuse a dealer contracting in his field of specialisation, as opposed to a layman. In the art market, however, mistakes as to authenticity made by professionals have sometimes been regarded as excusable, because of the practical difficulty of detecting forgeries or other circumstances, such as the erroneous opinion of an expert or the inclusion of the work in a *catalogue raisonné*.[39]

A mistake is always excusable if the seller was in breach of his duty to inform.[40]

5. Absence of authenticity or of certainty about authenticity

The claimant is required to demonstrate that the sought-after substantial quality of the object does not exist.

In order to determine whether or not a work of art is authentic, and therefore whether there was an operable mistake at the time when the contract was entered into, the courts may rely on elements subsequent to the sale.[41] This approach takes advantage of possible new scientific findings and available data.

Since the possibility of establishing authenticity with certainty is a substantial quality,[42] the question is no longer "whether the work of art is authentic, but whether it is doubtful".[43] The buyer need not prove that the object is not

38 Duret-Robert, *op. cit.* note 5 pp. 174-175, n. 6.38.
39 CA-Versailles, 10 February 1994 (print), *D.* 1994 inf. rap. p. 102; Françoise Châtelain, Christian Pattyn and Jean Châtelain, *Œuvres d'art et objets de collection en droit français*, (3rd edn, 1997, Paris), p. 144. See below, chapter 5, note 2 for a definition of *catalogue raisonné*.
40 Malaurie and Aynès, *op. cit.* note 27, n. 115.
41 Cass. 1ère civ., 13 December 1983 (the '*Poussin* case'; see above, note 23), *Bull. civ.* 1983 I n. 293, *Defrénois* 1985 p. 505, *JCP* 1984 G II 20186, concl. Gulphes, *Gaz. Pal.* 1984 p. 156, note J. B., *D.* 1984 jur. p. 340, note Aubert; CA-Paris, 25 February 1994 (above, note 28). Some authors favour this approach (e.g., Duret-Robert, *op. cit.* note 5, p. 176, n. 6.40), while others consider that only facts at time of the sale should be relevant (e.g., Châtelain, *op. cit.* note 26, p. 73).
42 See above, note 30.
43 CA-Paris, 7 May 2001 (painting by van Gogh), cited in Duret-Robert, *op. cit.* note 5, p. 182, footnote 1 (free translation).

authentic, but only that there are serious doubts.[44] A sole contrary opinion is not sufficient to characterise the doubt, whether it is the opinion of the artist's heirs, an art historian, or even, surprisingly, the artist himself; the situation is different where the authenticity is doubted by a few experts, by the court-appointed expert, or by a laboratory of scientific analysis.[45]

6. Possibility of returning the work of art in its original condition

According to some authors and court decisions,[46] the buyer must be in a position to return the work of art in the same condition as when he received it. The difficulty in the context of forgeries is that the object might have been deteriorated during the tests undertaken to demonstrate that it is a fake or when it was cleaned. When the deterioration is significant, the courts may refuse to set the sale aside.[47]

ii) Consequences

1. Nullity claim

A contract entered into by virtue of a mistake as to authenticity is voidable, rather than void, but once it has been avoided, it is considered to be null *ab initio*. This nullity needs to be pronounced by the courts, upon the claim of the mistaken party ('*action en nullité*'; article 1117).

44 CA-Paris, 7 May 2001 (above, note 43; confirmed by Cass. 1ère civ., 25 May 2004, *Bull. civ.* 2004 I n. 152). *Contra*: TGI-Paris, 3 May 2000, *D.* 2000 inf. rap. p. 200; in this decision, the court required strict proof as to lack of authenticity, along the lines of earlier decisions (e.g., Cass. 1ère civ., 2 June 1981 (painting by van Ostade), *Bull. civ.* 1981 I n. 188, *Journ. des C.-P.* 1982 p. 65, *Défrénois* 1982 p. 997, obs. Aubert).
 For a summary of the development of law, see Duret-Robert, *op. cit.* note 5, pp. 178-182.
45 Châtelain *et al.*, *op. cit.* note 39, p. 154 and ref. cit.
46 Duret-Robert, *op. cit.* note 5, pp. 187-189 and ref. cit.
47 E.g., CA-Paris, 1 February 1966 (painting by Ruysch), *D.* 1966 p. 663. However, in some cases, the contract was set aside and the purchase price reimbursed, after deduction of an indemnity for the damage caused by the deterioration of the work (see CA-Paris, 12 February 1954, note 14). In a case involving the forgery of a painting by Thomas de Keyser, small sections of the painting had been removed in order to perform tests; the courts held that the sale could be nullified, because the deteriorations were not irreparable (CA-Versailles, 15 May 1997, cited in Duret-Robert, *op. cit.* note 5, p. 189 footnote 4).

Such a claim must be brought within a period of five years (article 1304), which starts running when the mistake has been irrefutably established (rather than merely suspected),[48] i.e. when serious doubts as to the authenticity may be established. Generally, this will only be when the court-appointed expert's conclusions are known by the parties.[49]

The French Senate[50] and most academics[51] also subject the claim to the absolute limitation period of thirty years from the date of the transaction (article 2262). They consider that this period sufficiently respects the interests of the defrauded buyer and the nature of the art market.

2. Restitution and damages

Once the contract has been held to be void, the buyer is obliged to return the disputed object and the seller to reimburse the purchase price, as well as all costs incurred by the buyer.

Mistake was traditionally considered not to give rise to an award of damages, unless the seller's behaviour was close to *dol*. However, in recent cases, some courts have awarded damages to the buyer even where the seller had neither acted in bad faith, nor committed any fault, while other courts continue to require bad faith or a fault on the part of the seller.[52]

The traditional approach remains that an obligation to indemnify is not based on article 1110 as such, but on a pre-contractual liability of tortious nature (articles 1382-1383). The buyer would have to establish that:

- he suffered a loss (e.g., expenses arising out of the contract or lost profits); and

48 Cass. 1ère civ., 31 May 1972 (painting by Cézanne), *Bull. civ.* 1972 I n. 142; Duret-Robert, *op. cit.* note 5, p. 247; Petit, *op. cit.* note 8, n. 88.
49 Duret-Robert, *op. cit.* note 5, p. 248.
50 Yann Gaillard, *Marché de l'Art: les chances de la France*, Information Report 330 (1998-1999), Commission of Finances, available on: http://www.senat.fr/rap/r98-330/r98-330.html (accessed on 30 June 2005), § II. c. 3.
51 Châtelain *et al.*, *op. cit.* note 39, p. 151; Mazeaud and Chabas, *op. cit.* note 26, n. 316; Duret-Robert, *op. cit.* note 5, p. 248; Tharreau, *op. cit.* note 20, part III, p. 6.
52 See examples in Duret-Robert, *op. cit.* note 5, pp. 191-192.

- the damage was caused by the seller's fault, i.e. by the infringement, even if it was not intended, of his duty to inform.[53] Courts are stricter towards a professional seller, who is presumed to be at fault.

This claim is subject to a ten-year limitation period (article 2270-1), starting to run from the date when the damage occurred or was discovered by the victim.

The mistaken party may be liable to pay damages to the other party, if the nullity was pronounced on the basis of a negligent (but excusable) mistake and caused damage to the other party.[54]

b) Dol

Very few cases are successfully pleaded under *dol*,[55] because of the difficulties in proving an intention to deceive.

i) Notion and Conditions

Article 1116(1) provides that *dol* is a vitiating factor when the machinations of one party are such that it is obvious that, without them, the other party would not have contracted. There are two distinct elements: the dishonest dealing of one party and the mistake of the other party.

1. Dishonest dealing of the deceiving party

Dol may be active, if the seller uses schemes to make the buyer believe that the work is authentic, or lies about the authenticity. It may also be passive, if he conceals information which, had it been known by the buyer, would have caused him not to conclude the contract. This *réticence dolosive* may serve as a basis to avoid the contract only if it constitutes a breach of the seller's duty to inform.[56]

The courts treat dealers more strictly than laymen. For instance, a claim based on *dol* was rejected in a case where the seller, a descendant of the artist in question, but with

53　Petit, *op. cit.* note 8, n. 91; see also Ghestin, *op. cit.* note 27, n. 519; Mazeaud and Chabas, *op. cit.* note 26, n. 175.
54　Petit, *op. cit.* note 8, n. 92.
55　E.g. Cass. 1ère civ., 22 June 2004, *Bull. civ.* 2004 I n. 182, *RTD civ.* 2004 pp. 503-505, obs. Mestre and Fages; see also Châtelain *et al.*, *op. cit.* note 39, p. 141.
56　Cass. 1ère civ., 3 May 2000 (above, note 4).

no expertise in the area, had established a certificate of authenticity; Ghestin noted that the claim would have been allowed had the seller been a professional.[57]

2. Mistake on the part of the deceived party

The dol must have caused the buyer to conclude the contract, by provoking a mistake as to the authenticity or to the value of the work of art. Unlike an action based on a simple mistake, the mistake occasioned by *dol* need not relate to a substantial quality.

ii) Consequences

If the buyer would not have entered into the contract at all ('*dol principal*'), he may seek to avoid the contract (article 1117) and claim damages (article 1382).[58] If he would have contracted, but on different terms ('*dol incident*'), he is limited to an award of damages.[59]

The conditions and the limitation period of the *action en nullité* are the same as for the *erreur substantielle*. The claim for damages is subject to a ten-year limitation period (article 2270-1).

B. REMEDIES REGARDING THE PERFORMANCE OF THE CONTRACT

The seller has two main obligations: to deliver and to guarantee the object which he sells (article 1603). These are not frequently argued in practice in cases involving forgeries.[60]

57 Ghestin, *op. cit.* note 1, p. 141 and ref. cit.
58 For example: an individual had purchased three seventeenth-century paintings for 400,000 francs. The seller's conduct had caused the buyer to be mistaken as to the value of the paintings (they were worth only 140,000 francs according to the court-appointed experts): the seller had pretended to be an art critique, an expert in ancient paintings, as well as to have official functions, in order to gain the buyer's confidence, and he had lied about the value of the paintings. The courts nullified the contract on the ground of *dol* and awarded damages of 100,000 francs (Cass. 1ère civ., 1 February 1960, *Bull. civ.* 1960 I n. 67).
59 Duret-Robert, *op. cit.* note 5, p. 213.
60 E.g., TGI-Paris, 30 November 1967 (painting by a notorious artist), *D.* 1968 somm. p. 65; Cass. 1ère civ., 16 April 1991 (paintings by Delacroix), *Bull. civ.* 1991 I n. 145, *JCP* 1993 G II 21976, note Meau-Lautour; Cass. 1ère civ., 15 December 1981 (painting by van Ruisdael), *Bull. civ.* 1981 I n. 377. See Tharreau, *op. cit.* note 20, part IV, s. II/II.

a) The Seller's Duty of Delivery

The absence of delivery (defined in article 1604), or the delivery of an object which does not conform with the express or implied stipulations of the contract, entitles the buyer either to claim performance of the contract or to seek its rescission ('*action en résolution*'; article 1184), along with an award of damages (articles 1150-1151). The limitation period for such actions is thirty years from the date of the transaction (article 2262).

The rescission is similar to nullity for *erreur substantielle* or *dol*, since the contract is also declared retrospectively void. However, the court has a discretion to avoid the contract in the *action en résolution*, whereas it is bound to pronounce the nullity where mistake or *dol* have been established.[61]

b) The Seller's Liability for Defects

The seller is liable to the buyer in respect of hidden defects of the object sold which render it unfit for the purpose for which it was intended, or which so impair that use that the buyer would not have acquired it, or would only have given a lower price for it, had he known of them (article 1641). Where such defects have been established, the buyer has the choice either of returning the object and having the price repaid or of keeping the object and having a proportion of the price repaid (article 1644). The seller's liability is not dependent upon his knowledge of latent defects (article 1643). A good faith seller is only liable to reimburse the buyer the price, as well as any costs occasioned by the sale, whereas a bad faith seller is liable for all damages towards the buyer (articles 1644-1645). A professional seller is deemed to know what he is selling and will be held liable for damages without further proof that he was aware of the defects.[62] The seller's liability is excluded if the object was bought at the buyer's risk and this risk was real (*contrats aléatoires*).[63]

According to some academics, the seller's liability for defects should also apply to forgeries, because defects are

61 Barry Nicholas, *The French Law of Contract*, (2nd edn, 1992, Oxford), p. 81.
62 *Ibid.*, p. 82; Trigeaud, *op. cit.* note 19, p. 72.
63 Olivier Barret, *Répertoire de droit civil, volume X, Vente*, (1995, Paris), n. 1397.

to be understood not only as material defects, but also as the absence of a sought-after quality.[64] Other academics take the opposite view.[65]

The French courts have defined latent defects as those "rendering the object unfit for the purpose for which it was intended".[66] This definition excludes the extensive interpretations that had been made of article 1641. It is therefore not certain that an action based on liability for defects is still open in respect of cases involving forgeries.[67]

In any case, an action based on the seller's liability for defects is not appropriate for many reasons. First, the buyer must bring his action within a short time ('à bref délai': article 1648).[68] Secondly, it is excluded if the controversy as to the exact attribution arises after the sale,[69] whereas an *action en nullité* would be available in such cases. Thirdly, it may be difficult and costly to establish the lack of authenticity, whereas serious doubts as to authenticity are sufficient in an *action en nullité*. Finally, it has been argued that there should be parallelism between the means of the buyer and those of the seller in transactions involving problems of authenticity.[70]

64 Châtelain *et al., op. cit.* note 39, p. 141.
65 The absence of authenticity would be different from the absence of a quality in the sense of art. 1641: the former changes the nature of the object, whereas the latter, which is not essential to the object, only diminishes its value (Trigeaud, *op. cit.* note 19, p. 69; see also Michel Amaudruz, *La garantie des défauts de la chose vendue et la non-conformité de la chose vendue dans la loi uniforme sur la vente internationale des objets mobiliers corporels. Etude de droit comparé*, (1998, Lausanne), p. 44; Tharreau, *op. cit.* note 20, part IV, p. 6).
66 Cass. 1ère civ., 14 May 1996 (above, note 20; free translation).
67 Duret-Robert, *op. cit.* note 5, p. 152. A recent case denies the use of the liability against defects: "the mistake as to a substantial quality which is not an intrinsic flaw jeopardising the normal use of the object or its good functioning, is not a hidden defect and cannot give rise to the seller's liability for defects" (Cass. 1ère civ., 14 December 2004, not published, but available on: http://www.legifrance.gouv.fr, appeal no. 01-03523; free translation).
68 Châtelain *et al., op. cit.* note 39, p. 141. However, this limitation period starts running upon the discovery of the defect (Barret, *op. cit.* note 63, n. 1490). It has therefore been said that the buyer's claim is no longer subject to any limitation period, provided he acts diligently upon discovery of the defect (Jérôme Huet, *Traité de droit civil, Les principaux contrats spéciaux*, (1996, Paris), n. 11347).
69 Cass. 1ère civ., 16 April 1991 (above, note 60).
70 Duret-Robert, *op. cit.* note 5, p. 152.

CHAPTER 4

ENGLISH LAW

I. THE SELLER'S DUTY TO INFORM

There is no duty to disclose information in negotiations, apart from very special circumstances, such as in fiduciary relationships or contracts of utmost good faith.[1] Moreover, it has been held that "there is no legal obligation on the vendor to inform the purchaser that he is under a mistake, not induced by the act of the vendor".[2]

In a recent case, the English Court of Appeal was called upon to examine whether Christie's ought reasonably to have advised the buyer of material doubts as to the dating of vases prior to the purchase. They were described in the auction catalogue as "A pair of Louis XV porphyry and gilt-bronze two handled vases", but the buyer heard four years later a suggestion that they might be an imitation made in the mid-nineteenth century or later. The Court of Appeal considered that people who provide information in the nature of advice may assume a responsibility giving rise to a duty of care. But even in such a case, they "do not thereby normally undertake to draw attention to the obvious" or "to risks which are fanciful". The characteristics and experience of the recipient of the information are relevant to determine the extent of the advice to be given.[3] The Court of Appeal took the view that the vases were indeed

1 John Cartwright, *Unequal Bargaining, A Study of Vitiating Factors in the Formation of Contracts*, Oxford 1991, p. 90. See also J. Beatson, *Anson's Law of Contract*, (28th edn, 2002, Oxford), p. 263 *et seq.* and Günter Treitel, *The Law of Contract*, (11th edn, 2003, London), p. 390 *et seq.*
2 *Smith v. Hughes* (1870-71) LR 6 Q.B. 597, at 607. However, where the seller knows that the buyer has made a mistake about the terms of the contract, it is not enforceable (Ewan McKendrick (ed.), *Sale of Goods*, (2000, London), n. 7-018).
3 *Taylor Thomson v. Christie Manson & Woods Ltd and others* [2005] EWCA Civ 555, n. 95, noted by A.H. Hudson in (2005) X *Art Antiquity and Law* 307.

Louis XV and, as Christie's had reasonably held this certain and definite opinion, there was no reason why it should have expressed any doubts to the buyer.[4] Had Christie's breached its duty of information, it would have been liable to pay the difference between the price paid by the purchaser for the vases and their value at auction if Christie's had described them as "probably by Louis XV".[5]

II. THE GUARANTEE OF AUTHENTICITY

The existence of a guarantee of authenticity depends on the nature of the statements made or assurances given by the seller in the course of negotiations. As has been noted by Nourse L.J.:

> Frequently the seller makes an attribution to an artist, although the degree of confidence with which he does so may vary considerably. In some cases the attribution may be of sufficient gravity to become a condition of the contract. In others it may be no more than a warranty, either collateral or as a term of the contract. Or it may have no contractual effect at all. Which of these is in point may depend on the circumstances of the sale; there being, for example, a difference between a sale by one dealer to another and one by a dealer to a private buyer.[6]

In some instances, the contract determines with clarity what legal effect is to be given to a statement as to authenticity. For instance, in its Conditions of Sale, Christie's warrants that any property which is stated without qualification to be the work of a named author is authentic;[7] such a statement is a term of the contract.

However, in most cases, the intention of the parties is less clear and will need to be interpreted. In art transactions, courts tend to be reluctant to attach contractual force to

4 *Ibid.*, nn. 151 and 157.
5 *Ibid.*, n. 130.
6 *Harlingdon and Leinster Enterprises Ltd v. Christopher Hull Fine Art Ltd*
 [1991] 1 Q.B. 564, at 568, [1990] 3 W.L.R. 13, [1990] 1 All E.R. 737.
7 Appendix III, art. 6, below, p. 74.

statements concerning authenticity.[8] If the parties wish to warrant the authenticity of the object being sold, they must do so in clear, express language.[9]

A. STATEMENT OF OPINION

A statement has no legal effect if it is only a statement of the maker's opinion or belief, and not a positive assertion that the fact stated is true. Considering the difficulties inherent in dating a Buddha sculpture,[10] or in tracing pictures painted "some centuries back",[11] statements made as to the date or the authorship of the works have been held to be expressions of opinion rather than of fact.

In a sense, references to particular artists are always expressions of opinion. However, they involve a statement of fact – which is difficult to verify – and may become a term of the principal contract,[12] constitute a collateral contract or be a representation.

B. TERM OF THE CONTRACT

A statement forms part of the contract where one or both parties intended that there should be contractual liability in respect of its accuracy.[13] Terms are expressly inserted by the parties into their contract[14] or implied by the law, in particular sections 13-14 of the Sale of Goods Act 1979 ('SGA').

Where one party possesses superior knowledge and skill relating to the subject-matter, his statement will tend to be regarded as a term.[15] It has even been contended that "a statement as to the quality or state of the goods by a

8 Norman Palmer, 'Misattribution and the Meaning of Forgery: The De Balkany Litigation' (1996) I *Art Antiquity and Law*, pp. 49-58, at p. 49.

9 *Techarungreungkit v. Götz* [2003] E.W.H.C. 58, n. 70; see also *Drake v. Thos Agnew & Sons Ltd* [2002] E.W.H.C. 294, n. 25 and the note by A.H. Hudson, (2003) VIII *Art Antiquity and Law* 201.

10 *Techarungreungkit v. Götz* (above, note 9) n. 70.

11 *Jendwine v. Slade* (1797) 2 Esp. 571, at 573.

12 See *Drake v. Agnew* (above, note 9) n. 26.

13 Beatson, *op. cit.* note 1, p. 128.

14 For instance, in *Peco Arts v. Hazlitt Gallery Ltd* [1983] 3 All E.R. 193, [1983] 1 W.L.R. 1315, both parties agreed that it was an express term of the contract that the subject-matter of the sale was an original drawing signed and inscribed by the artist.

15 See Beatson, *op. cit.* note 1, pp. 129-130; Treitel, *op. cit.* note 1, pp. 354-355.

seller will almost invariably be held to be a term of the contract if the seller is a dealer in the goods".[16]

Some cases qualify statements as to the authenticity of works of art as terms. For instance, a statement that certain pictures were by Canaletto was held in one case to be a warranty.[17] In *Leaf v. International Galleries*, it was held that: "there was a term in the contract as to the quality of the subject matter: namely, as to the person by whom the picture was painted – that it was by Constable";[18] while Denning L.J. held that it was a condition, the majority considered that it was a warranty. If the parties regard the term as fundamental, it is classified as a condition, whereas if it was regarded as subsidiary or collateral, the term is a warranty.[19]

However, in *Harlingdon & Leinster Enterprises Ltd v. Christopher Hull Fine Art Ltd* and in *Richard Drake v. Thos Agnew & Sons Ltd*, statements as to authorship were held not to be contractual terms. These cases are of considerable significance for the purposes of this book. They examine the question of implied terms in art contracts and demonstrate the policy decision made by the judges with respect to the sale of forgeries.

The facts in *Harlingdon* were as follows. In 1984, the claimant art dealers purchased from the defendant art dealers a painting described in an auction catalogue as being by Gabriele Münter, a German expressionist artist, for £6,000. Before entering into the contract, the claimants inspected the painting and the catalogue. The sellers emphasised their lack of expertise in Münter's work, in particular regarding the painting at sale. The invoice

16 Patrick S. Atiyah, John N. Adams and Hector Macqueen, *The Sale of Goods*, (10th edn, 2001, Harlow), p. 87.

17 *Power v. Barham* (1836) 4 Ad. & E. 473, at 475. This case was distinguished from *Jendwine v. Slade* (above, note 11) on the ground that Canaletto was "not a very old painter".

18 *Leaf v. International Galleries (A Firm)* [1950] 2 K.B. 86, at 89 (*per* Denning L.J.). In order to determine whether the seller would have been prepared to give a contractual undertaking that the picture was "by John Constable", it may be relevant to consider whether the price was adequate (see Treitel, *op. cit.* note 1, p. 293, footnote 71).

19 *Oscar Chess Ltd v. Williams* [1957] 1 All E.R. 325, at 328, [1957] 1 W.L.R. 370; s. 61(1) SGA. In order to simplify the presentation, a third category of terms, 'intermediate or innominate terms', has been omitted.

described the painting as being by Münter. Later, it was discovered to be a forgery, which was virtually worthless. The buyers alleged that the sellers were in breach of the implied terms that the painting would correspond to its description as Münter's work and that it would be of merchantable quality. Both arguments were rejected.

On the issue of the sale by description, the majority held that the description had to be influential in the sale so as to become an essential term or condition of the contract. Since the sellers had clearly disclaimed expert knowledge, the buyers had not relied on their description of the painting as being by Münter, but rather on their own assessment of the work. Therefore, a common intention that the attribution should be a term of the contract could not be imputed to the parties.[20] Dissenting, Stuart-Smith L.J. took the view that the attribution was a term of the contract, which did not require proof that the purchaser entered the contract in reliance on this statement.[21]

The reference to Münter in the invoice was, in the view of the majority, a "convenient mode of reference to a particular picture".[22]

Regarding fitness for purpose and merchantability, Nourse L.J. held in particular that the painting was fit for the purposes for which paintings were commonly bought, namely resale (even at a loss) and/or aesthetic appreciation.[23] This view was contested by Stuart-Smith L.J.: both parties knew that the purpose of this contract was resale by the claimants of a painting by Münter.[24]

It appears that the division of opinion between the judges turned upon their perception of how the art market operates.[25] Nourse L.J. indeed expressly referred to the principle 'caveat emptor' ('let the buyer beware'), because of

20 *Harlingdon & Leinster v. Hull Fine Art* (above, note 6) at 574 (*per* Nourse L.J.) and at 585 (*per* Slade L.J.).
21 *Ibid.*, at 578-579 (*per* Stuart-Smith L.J.).
22 *Ibid.*, at 586 (*per* Slade L.J.).
23 *Ibid.*, at 576 (*per* Nourse L.J.).
24 *Ibid.*, at 583 (*per* Stuart-Smith L.J.).
25 Richard Clutterbuck, 'Implied Terms in the Art World' (1990) *J.B.L.*, pp. 180-181, at p. 181.

the "potential arguability of almost any attribution".[26] This decision was criticised by many commentators. It has been contended that it undermines the very spirit of the Sale of Goods Act, sections 12-15 of which were designed to "redress the bargaining power between buyer and seller" and, therefore, to protect the buyer.[27] It is not certain that the same result would have been reached in a consumer sale, which is subject to the control of any exclusion of liability.

Harlingdon was applied in *Drake*, which involved the sale of a painting by the defendant, a well- known specialist in Old Master paintings, to the claimant, whose agent was a dishonest art dealer. The sales brochure, the seller's correspondence and the invoice referred to the artist "Sir Anthony van Dyck (1599-1641)". The seller was convinced that the painting was by that artist, but expressly stated in his correspondence to the buyer's agent (never shown to the buyer) the existence of doubts. The High Court held that there was no term that the painting was by van Dyck and therefore no sale by description.[28] Moreover, the work was a "fine painting ... suitable for appreciation and display in its own right".[29]

Finally, in *Hoos v. Weber*, a case which involved a doubtful Rembrandt self-portrait catalogued by Sotheby's as being by the artist, but with an express reference to doubts of an expert, the statement of the name of the artist was considered to be an opinion, as this was specified in the catalogue.[30]

These three cases denying that a statement as to authenticity is a term of the contract may be explained by reference to the particular circumstances: doubts drawn to the attention of the buyer or his agent (*Drake* and *Hoos*); express indication that the statement is one of opinion or

26 *Harlingdon & Leinster v. Hull Fine Art* (above, note 6) at 578 (*per* Nourse L.J.).
27 See L.A. Lawrenson, 'The Sale of Goods by Description - A Return to Caveat Emptor?' (1991) 54(1), *M.L.R.*, pp. 122-126.
28 *Drake v. Agnew* (above, note 9) n. 32. However, in a case involving mascots that turned out not to have been coloured by Lalique, a sale by description was recognised (*Ojjeh v. Waller and Another* [1999] C.L.Y. 4405).
29 *Drake v. Agnew* (above, note 9) n. 40.
30 *Hoos and Others v. Weber and Another* [1974] 232 E.G. 1379.

belief (*Hoos*); or disclaimer of knowledge in a sale between dealers (*Harlingdon*).

C. COLLATERAL CONTRACT

If the seller making the statement of authenticity undertakes that it is true, it may be construed as a contract or warranty collateral to the principal agreement, provided the necessary contractual intention is present.

D. REPRESENTATION

If no contractual effect is to be given to the statement, it may be a representation, i.e. a statement of fact which induces a party to enter into a contract but does not form part of it nor of a collateral contract. A representation may however become a term of the contract or form the basis of a collateral contract.

A statement expressed as an opinion may be a representation if it is not honestly held, for instance, if a person says that he thinks a picture is a Rembrandt when he thinks it is a copy,[31] or if its author possesses a special knowledge or skill in relation to the subject-matter.[32]

A few cases expressly refer to the representation made by the seller that the work of art is by a particular artist.[33] Such representation is "of great importance, which [goes] to the root of the contract".[34]

III. THE REMEDIES OF THE BUYER (INCLUDING THE PROBLEM OF LIMITATION PERIODS)

Where authenticity is the subject-matter of a term in the contract or a collateral warranty, the defrauded buyer may invoke a breach of contract. Mistake and misrepresentation are mainly relevant where the accuracy of statements as to authenticity has not been guaranteed contractually.

31 Treitel, *op. cit.* note 1, at p. 331.
32 See *Smith v. Land and House Property Corporation* (1885) LR 28 Ch.D. 7, at 15.
33 E.g., works represented as being by Poussin (*Lomi v. Tucker* (1829) 4 Car. & P. 15), Rembrandt (*Sewhanberg v. Buchanan* (1832) 5 Car. & P. 172) or Constable (*Leaf v. International Galleries*, above, note 18).
34 *Leaf v. International Galleries* (above, note 18) at 92.

A. Remedies Regarding the Formation of the Contract

Actions based on mistake and misrepresentation are available to the buyer only if the risk of a misapprehension of the facts was not contractually allocated to him and if he would not have entered into the contract had he known that the work of art was not authentic.

a) Mistake

The situations in which a contract will be void *ab initio* (at common law) or voidable (in equity) are contained in a disparate group of cases.[35] The policy is to limit the ambit of mistake: there is a presumption that "the law ought to uphold rather than destroy apparent contracts".[36] Mistake has to be either shared by both parties or, if only one party is mistaken, the other party must be aware of it or the circumstances must be such that he may be taken to be aware of it.

It is generally considered that mistake about the lack of authenticity of works of art offers no remedy to the defrauded buyer: the mistake is one as to quality, which does not make a contract void, however fundamental the quality is.[37] Lord Atkin, in a well-known obiter statement in *Bell v. Lever Brothers Ltd* stated:

> A. buys a picture from B.; both A. and B. believe it to be the work of an old master, and a high price is paid. It turns out to be a modern copy. A. has no remedy in the absence of representation or warranty.[38]

This was confirmed in *Leaf v. International Galleries*, where – although the buyer only argued misrepresentation – it was

35 Equity may give relief for mistakes which have no effect at common law, by setting aside the contract on terms with retrospective effect, but the scope of such relief has been significantly reduced by recent authority (*The Great Peace Shipping Ltd v. Tsavliris Salvage (International) Ltd* [2003] Q.B. 679, at 708 *et seq.*, [2002] 3 W.L.R. 1617, [2002] 4 All E.R. 689, [2002] 2 Lloyd's Rep. 653).

36 *Associated Japanese Bank (International) Ltd v. Crédit du Nord SA* [1988] 1 W.L.R. 255, at 258, [1988] 3 All E.R. 902. See also *Chitty on Contracts, volume I, General Principles,* (29th edn, 2004, London), n. 5-007 about the underlying policy.

37 See *Harrison & Jones Ltd v. Bunten & Lancaster Ltd* [1953] 1 Lloyd's Rep. 318, at 326, [1953] 1 All E.R. 903.

38 *Bell v. Lever Brothers Ltd* [1932] A.C. 161, at 224, [1931] All E.R. Rep 1.

said that a contract for the sale of a picture would not be void for mistake if the parties mistakenly believed that it was by Constable.[39] There was only a "difference in quality and in value rather than in the substance of the thing itself".[40]

However, according to other dicta or decisions, a mistake as to quality can sometimes render the contract void if it is sufficiently fundamental; this would be the case where the mistake "render[s] the subject-matter of the contract essentially and radically different from the subject-matter which the parties believed to exist".[41]

It has been suggested that there would be a fundamental mistake if the quality is so important to the parties that it is used to identify the thing. The test would be to imagine asking the parties, immediately after they had concluded the contract, what its subject-matter was. If they both answer "a Constable" (which is most likely) rather than "a picture", the mistake would be as to the subject-matter.[42] Therefore, following Treitel, "it is submitted that, on the bare facts given by Lord Atkin, the contract should be held void" for common mistake.[43] The situation would obviously be different if the picture were sold speculatively. Treitel's view does not, to date, appear to have been followed. For instance, Bridge states that "authorship for a painting is not part of the identity of specific goods for the purpose of common mistake".[44]

If the buyer believes that the work of art is authentic, but the seller is aware that it is a forgery, the mistake would be unilateral. Such a mistake is relevant only if it relates to the terms of the contract, for example if the picture is believed by the buyer to be *warranted* to be authentic.[45]

39 *Leaf v. International Galleries* (above, note 18) at 89.
40 *Ibid.*, at 94.
41 *Associated Japanese Bank* (above, note 36) at 258, approved in *The Great Peace* (above, note 35) at 90-91. See also: *Bell v. Lever Bros Ltd* (above, note 38) at 218 and 235; *Nicholson & Venn v. Smith-Marriott* [1947] 177 L.T. 189, where, on sale of linen falsely described as Carolingian, Hallett J. would have been prepared to treat the contract as void for mistake. For a general view: see Judah Philip Benjamin, *Benjamin's Sale of Goods*, (6th edn, 2002, London), n. 3-021; McKendrick, *op. cit.* note 2, n. 7-022-025.
42 See Treitel, *op. cit.* note 1, pp. 292-293.
43 Treitel, *op. cit.* note 1, p. 293 (see also p. 304 for unilateral mistake).
44 Michael G. Bridge, *The Sale of Goods*, (1997, Oxford), p. 289.
45 See *Smith v. Hughes* (above, note 2) at 608; Benjamin, *op. cit.* note 41, n. 3-017.

If the mistake is operative and the contract is void or has been set aside by the courts, the buyer may secure restitution of the purchase price by seeking the reversal of the seller's unjust enrichment.[46] The limitation period for such an action is six years from the date of the breach of contract.[47]

By relying on mistake at law, the defrauded buyer may benefit from a postponement of the limitation period pursuant to section 32(1)(c) of the Limitation Act 1980 ('LA'). This provision states that the limitation period shall not begin to run until the claimant has discovered the mistake or could with reasonable diligence have discovered it. A claimant with specialised knowledge may find time running against him from an earlier date than a layman.[48]

Section 32(1)(c) was successfully pleaded in *Peco Arts Inc. v. Hazlitt Gallery Ltd.* In this case, the claimant, on the recommendation of a specialist, had bought from the defendant, a reputable art dealer, a drawing believed to be original. It was discovered to be a reproduction ten years after the purchase, upon a second valuation of the object. The seller admitted liability to return the price as money paid under a common mistake. The only issue was whether the claim was time-barred. The claimant was held to have exercised reasonable diligence, which meant "simply the doing of that which an ordinarily prudent buyer and possessor of a valuable work of art would do having regard to all the circumstances, including the circumstances of the purchase";[49] an independent authentification would not have been necessary in that case.

b) Misrepresentation

Unless a false representation has acquired contractual force,[50] it merely renders the contract voidable *ab initio* at

46 Graham Virgo, *The Principles of the Law of Restitution*, (1999, Oxford), p. 178.
47 Section 5 LA is applicable by analogy (Virgo, *op. cit.* note 46, p. 768).
48 Ruth Redmond-Cooper, 'Time Limits in Art and Antiquity Claims' (1999) IV *Art Antiquity and Law*, pp. 323-346, at p. 329.
49 *Peco Arts v. Hazlitt* (above, note 14) at 199.
50 In such a case, the buyer continues to enjoy a right to rescind for misrepresentation (s. 1(a) MA). Alternatively, he may rescind the contract for breach and is entitled as of right to recover damages for breach of contract.

the suit of the party misled (by notifying the other party or by applying to the court for an order of rescission) and may give rise to damages.[51] Upon rescission of the contract, the seller must restore the price, and the buyer the thing which was sold.

The remedies for misrepresentation are available if the representation is unambiguous and material and if the buyer has relied on it.[52]

If the seller falsely represents that a work is by a particular artist, although he knows that it is wrong, or does not believe that it is true, or finally does not care whether it is true or false, the misrepresentation is *fraudulent*.[53] The contract is voidable and damages may be claimed in the tort of deceit.

If the false statement is *negligently* made (i.e. honestly but without reasonable care), the buyer may be entitled to rescind the contract and recover damages. At common law, a duty of care arising from a special relationship between the parties is required.[54] In parallel to the possible rescission,[55] liability in damages for negligent misrepresentation may also arise under section 2(1) of the Misrepresentation Act 1967 ('MA'), unless the seller succeeds in proving that he had reasonable ground to believe and did believe that the facts represented were true. In practice, the seller should have no great difficulties in showing this by providing, for instance, an expert opinion about the authenticity.

51 For details as to the extent of damages for each type of misrepresentation: see Norman Palmer, 'The Civil Liability of the Professional Appraiser or Attributer of Works of Art under English Domestic Law' in Quentin Byrne-Sutton and Marc-André Renold (eds), *L'expertise dans la vente d'objets d'art – Aspects juridiques et pratiques*, Zurich 1992, pp. 19-36, at pp. 21-22.

52 Treitel, *op. cit.* note 1, p. 335 *et seq.*

53 See *Derry v. Peek* (1889) L.R. 14 App. Cas. 337, at 374.

54 The buyer would be suing under the tort of negligent misstatement (principle of *Hedley Byrne & Co Ltd v. Heller & Partners Ltd* [1964] A.C. 465, [1963] 3 W.L.R. 101, [1963] 2 All E.R. 575, [1963] 1 Lloyd's Rep. 485). There may be a duty of care if the buyer relied on the seller's superior knowledge and experience (see *Esso Petroleum Co Ltd v. Mardon* [1976] Q.B. 801, [1976] 2 All E.R. 5, [1976] 2 Lloyd's Rep. 305, [1976] 2 W.L.R. 583).

55 The court has the discretion to award damages in lieu of rescission under s. 2(2) MA.

Finally, if the false statement is made without fraud or negligence, the misrepresentation is *innocent*. The available remedies are either the rescission of the contract, along with an indemnity,[56] or – if it is equitable to maintain the contract – damages in lieu of rescission (section 2(2) MA). There are conflicting views as to whether the court can award damages if the claimant has lost his right to rescind,[57] for instance by lapse of time.

The equitable remedy of rescission for innocent misrepresentation seems to be available in contracts of sale.[58] With respect to works of art which turn out to be forgeries, the main issue is often to determine whether the right to rescind is barred by lapse of time (equitable doctrine of laches).

Leaf v. International Galleries concerned the sale of a picture *Salisbury Cathedral*, which the sellers innocently misrepresented to have been painted by Constable. The buyer took delivery of the picture and kept it for five years. When he discovered that it was not a Constable, he sought to rescind the sale for innocent misrepresentation. It was held that his right to rescind was barred by lapse of time, five years being "much more than a reasonable time". Denning L.J. specified that since a claim to reject for breach of condition would be barred under section 35 SGA (because the buyer had "accepted the picture" and had "ample opportunity for examination in the first days after he had bought it"), *a fortiori* a claim to rescission for innocent misrepresentation was also barred.[59] Jenkins L.J. emphasised the importance of security of transactions: "contracts such as this cannot be kept open and subject to the possibility of rescission indefinitely".[60] Similarly,

56 An indemnity may be awarded in respect of certain expenses, but would not extend to lost profits.

57 See Treitel, *op. cit.* note 1, pp. 358-359 and 377; Beatson, *op. cit.* note 1, p. 258.

58 Treitel, *op. cit.* note 1, pp. 374-375; see Atiyah *et al.*, *op. cit.* note 16, p. 529 *et seq.*

59 *Leaf v. International Galleries* (above, note 18) at 91 (*per* Denning L.J.). Some academics question whether this decision could be overturned as a result of s. 1(a) MA whose effect is that the incorporation of a misrepresentation as a term of the contract does not take away the right to rescind (Bridge, *op. cit.* note 44, p. 189; Atiyah *et al.*, *op. cit.* note 16, p. 532).

60 *Ibid.*, at 92 (*per* Jenkins L.J.).

Evershed M.R. noted that on acceptance of the delivery of the work of art, "there is an end to that particular transaction, ... otherwise business dealings in these things would become hazardous, difficult and uncertain", especially as "the attribution of works of art to particular artists is often a matter of great controversy", which may result in "most costly and difficult litigation".[61] It was noted in *Leaf* that the buyer could have obtained damages for breach of warranty, had he claimed them.

Thus, in innocent (and probably negligent) misrepresentation, the passage of time may preclude rescission even if the buyer has no knowledge of the untruth of the representation. Conversely, if the misrepresentation is fraudulent, lapse of time is not a bar to rescission: the time starts to run from the date when the fraud is discovered, or could have been discovered with reasonable diligence.[62]

Another bar to rescission relevant in contracts involving forgeries might be the inability to restore, if, in the course of tests aimed at demonstrating inauthenticity, the buyer has caused the work to deteriorate. This bar, which is to be construed strictly,[63] is quite unlikely to succeed, since the subject-matter of the misrepresentation is the authenticity.

B. REMEDIES REGARDING THE PERFORMANCE OF THE CONTRACT

The classification of a term as a condition or a warranty determines the legal remedies available in the event of its breach. Breach of a condition gives the innocent party the right to treat himself as discharged from the contract and to claim damages, while breach of a warranty generally[64] only gives rise to a claim for damages (sections 11(3) and 61(1) SGA).

61 *Ibid.*, at 94-95 (*per* Evershed M.R.).
62 Section 32(1)(c) LA; McKendrick, *op. cit.* note 2, n. 7-065.
63 Beatson, *op. cit.* note 1, p. 255.
64 Rescission is available in two situations involving warranties: 1° A misrepresentation incorporated as a warranty may give rise to a right to rescind the contract for misrepresentation; 2° Pursuant to s. 48A and 48C SGA, a buyer who deals as a consumer may rescind the contract with regard to non-conforming goods; this includes goods which do not conform to an express warranty (s. 48F).

The distinction between 'condition' and 'warranty' is immaterial if, because of lapse of time, the buyer is deemed to have accepted the goods (section 35(4)-(5) SGA). In such a case, the buyer is, at best, restricted to a claim in damages (section 11(4) SGA).[65] Since the courts are strict as to the period during which the buyer must examine the work,[66] it is most likely that, even if a statement as to authenticity were held to be a condition, it would be treated as a warranty. The buyer would be limited to a claim for damages, which would *prima facie* be the difference between the value of the forgery and the value of the work, had it been authentic (section 53(2)-(3) SGA).

Should there be no problem of lapse of time, the breach of the condition would entitle the buyer to rescind the contract, with the effect of returning the forgery to the seller, being reimbursed the purchase price and claiming damages (e.g., lost profits).

If the seller knowingly stated that the work of art was authentic and the statement became a term of the contract, such fraud would justify rescission and damages in tort.

Where the statement as to authenticity is construed as a collateral contract, the buyer has a right to bring a claim for damages.[67]

Pursuant to section 5 LA, the buyer must commence his action founded on the contract within six years from the date of the breach, i.e. from the delivery of the forgery. However, where the action is based on fraud of the seller or is for relief from the consequences of mistake, the period does not begin to run until the buyer has discovered the fraud or mistake, or could with reasonable diligence have discovered it (section 32 LA).[68]

65 *Oscar Chess Ltd v. Williams* (above, note 19) at 328.
66 *Leaf v. International Galleries* (above, note 18).
67 Beatson, *op. cit.* note 1, p. 130; *De Lassalle v. Guildford* [1901] 2 K.B. 215, [1900–03] All E.R. Rep. 495 and *Esso Petroleum Co Ltd v. Mardon* (above, note 54). Benjamin notes that breach of a collateral contract may entitle the promisee to treat the main contract as discharged (Benjamin, *op. cit.* note 41, n. 10-014).
68 Section 32 will apply only where the basis of the cause of action is mistake or fraud. If the action is essentially one for breach of contract, the exception will not apply (Redmond-Cooper, *op. cit.* note 48, p. 328).

C. EXCURSUS: THE TRADE DESCRIPTIONS ACT 1968[69]

The defrauded buyer may rely on the Trade Descriptions Act in order to seek compensation, if the seller is a professional. It was held in *May v. Vincent* that the entry in an auction catalogue of a watercolour "by J.M.W. Turner, RA" was a false trade description under section 1(1)(a) if the attribution was erroneous. The court rejected the defendant's argument that the Act should not apply to the art world, which dealt in opinions and not in facts. The disclaimer warning bidders that statements as to the authenticity were statements of opinion was irrelevant.[70] This decision might be a "significant back door route by which the disappointed buyers, unable to pursue civil claims because of the restrictive policy espoused in cases like *Leaf* and *Harlingdon*, may nevertheless hold their sellers in compliance with the terms of the attribution".[71]

69 This criminal statute also has civil consequences: the court can award compensation in addition to convicting the defendant (Palmer, *op. cit.* note 51, p. 27).

70 *May v. Vincent* [1991] E.G. 144, (1991) 10 Tr. L.R. 1.

71 Palmer, *op. cit.* note 51.

CHAPTER 5

COMPARISON AND EVALUATION OF THE SOLUTIONS

I. THE SELLER'S DUTY TO INFORM

A. COMPARISON

Under Swiss and French law, the seller has a duty to inform, if he possesses more knowledge than the buyer with respect to the contemplated object and if it cannot reasonably be required of the buyer that he finds information about the authenticity by himself. In striking contrast, there is no general duty to inform under English law, even where the seller is aware that the buyer is mistaken as to authenticity, provided he neither induced the misapprehension nor was subject to a duty of care.

B. EVALUATION

The buyer should take all reasonable steps to ensure that the contemplated work of art is authentic, especially if its price is significant. By unduly extending the seller's obligation, the buyer will be discouraged from seeking independently the relevant information and it would be unfair towards others who made the intellectual efforts and used financial resources to establish the facts accurately.[1]

How far should the buyer's investigation go? While easily available documentation, such as *catalogues raisonnés*,[2]

1 See for instance Philippe Malaurie and Laurent Aynès, *Cours de droit civil, volume 2, Contrats et quasi-contrats*, (11th edn, 2001, Paris), p. 91, n. 109; Jean Châtelain, 'L'objet d'art, Objet de collection' in *Etudes offertes à Jacques Flour*, (1979, Paris), pp. 63-94, at p. 80.

2 "A *catalogue raisonné* is an annotated, illustrated book of a particular artist's works usually prepared by art historians, scholars or dealers. The intent is to be definitive and all-inclusive. Thus, inclusion of an artwork in a *catalogue raisonné* is evidence of authenticity, while non-inclusion suggests that the work is not genuine" (Stephen Mark Levy, 'Authentification and Appraisal of Artwork' in Roy S. Kaufmann (ed.), *Art Law Handbook*, (2000, New York), pp. 829-895, at p. 850).

should be examined, it would be excessive to ask the buyer to have the work authenticated, in the event that the seller has not already had it done. The buyer may wish to seek impartial and authoritative information on authenticity provided by certain organisations, such as the Art Authentication Service of the International Foundation for Art Research in New York,[3] the Swiss Institute for Art Research[4] or the Art Loss Register, whose databases also record identified fakes.[5]

The extent of the duty to inform should mainly depend on the respective knowledge of the parties in the specific area (including whether either or both are assisted by a professional in the course of the transaction). The Swiss and French solutions are, in our view, appropriate to the uncertainty of the art market and its exposure to fraud.

II. THE GUARANTEE OF AUTHENTICITY

A. COMPARISON

The guarantee of authenticity under English law is essentially contractual, while it is to a great extent determined by statutes and case-law in the French and Swiss legal systems. In France, the rules were developed under the doctrine of *erreur substantielle*, whereas in Switzerland, they originate from the seller's liability in respect of defects.

A guarantee is quite easily recognised in France, as long as there were no initial doubts concerning authenticity. The 1981 Decree defines the existence and extent of a guarantee. The language used in the documents, especially the invoice, has a crucial importance. Conversely, English cases show that a guarantee may be denied even where the work of art was described by the seller as being by a particular artist, for instance in a sales catalogue or on the invoice.

3 http://www.ifar.org/auth_main.htm (accessed on 30 June 2005).
4 http://www2.unil.ch/isea/index.html (accessed on 30 June 2005).
5 http://www.artloss.com/Default.asp (accessed on 30 June 2005).

Swiss law goes further than French law, by accepting a tacit guarantee where the purchase price is commensurate with that which would have been paid for an original. In the absence of express statements, French law would generally require a combination of elements, such as the price or the quality of the seller.

In contrast to French and Swiss courts, English judges often decline to attach legal force to statements concerning authenticity, which are generally regarded as statements of opinion. However, the intention of the parties may cause such statements to be considered as representations, terms of the contract or a collateral contract. The buyer who wants to argue that the statement is an implied term under section 13 SGA must demonstrate that he relied on the description, much in the same way as he would show his reliance to invoke a misrepresentation. Under French and Swiss law, the fact that the buyer relied on the statement is irrelevant to determine the existence of a guarantee; however, it is found in the concept of causation, necessary to trigger the remedies regarding the formation of the contract.

B. EVALUATION

Works of art are unique and may not be replaced by copies. Authenticity is paramount for most buyers, as has been recognised by Swiss and French courts. English cases surprisingly deny this by considering that the purposes for which pictures are commonly bought are aesthetic appreciation or resale. Thus, they ignore that "art does not live in a vacuum of aesthetic beauty",[6] but must be seen as a part of history and culture, as well as an investment.

The acknowledgment of the importance of authenticity justifies a wider recognition of guarantees of authenticity. However, a buyer should not benefit from such a guarantee, if the risk of lack of authenticity was contractually allocated to him, or if doubts as to authenticity were already present at the time the contract was concluded. The main criterion to determine whether or not a guarantee has been provided,

6 Peter Barry Skolnik, 'Art Forgery: The Art Market and Legal Considerations' 7 *Nova L.J.*, pp. 315-352 (1982-1983), at pp. 317-318.

or should be implied from the circumstances, is to refer to the existence of initial doubts (which the buyer had or should have had). Ghestin analysed French decisions on the basis of this factor.[7] This view has the advantage of taking account of the uncertainty in the art market and its exposure to fraud, but still requires that the buyer be vigilant.

The perception of doubts by the buyer may depend on his level of knowledge. However, the expressions defined in the 1981 French Decree, which are commonly used on the art market worldwide, should serve as an objective basis to ascertain whether or not express statements are to be held as a guarantee.

Initial doubts may also result from the circumstances, for instance if the work of art is bought at a flea market or if its price is disproportionately low. A tacit guarantee should be recognised in certain circumstances, for instance where the buyer pays a price which would have been that of an original or where the work is sold by or through well-known art galleries or auctioneers.

III. THE REMEDIES OF THE BUYER

A. COMPARISON

The remedies will vary considerably depending on the facts of the case, in particular on the state of mind of the parties, as well as on their professional status and experience in the field.

A central question is whether lack of authenticity is a difference in quality or in nature from the original. Swiss and English courts have decided in favour of the former interpretation. Consequently, the Swiss provisions on the seller's liability in respect of defects exclude the general ones for non-performance; in English law, mistake cannot be invoked. In both legal systems, there are opposing views which argue that forgeries do not possess the same identity

7 Jacques Ghestin, 'L'authenticité, l'erreur et le doute' in *Le droit privé français à la fin du XXe siècle, Etudes offertes à Pierre Catala*, (2001, Paris).

as authentic works of art. The question is controversial in French law, but of little relevance since *erreur substantielle* is generally an appropriate remedy.

In practice, Swiss and French law both treat the problem of forgeries essentially through mistake, leading to the nullity of the contract. It is likely, however, that the problem will be tackled under the sales provisions in Switzerland now that the seller's liability for defects is subject to a longer limitation period. English law focuses on the contract, or on misrepresentation; but in either case, it is quite likely that only damages will be available to the defrauded buyer.

a) Remedies Regarding the Formation of the Contract

The position adopted in Switzerland and France is fundamentally opposed to the English one. While the former legal systems focus mainly on freedom of contracting (*l'autonomie de la volonté*), the latter is based on the security of transactions. The conflict between the protection of the consent and the protection of the contract is at the heart of the justification and extent of the available remedies.

i) *Mistake and Innocent/Negligent Misrepresentation*

The Swiss *erreur de base* and the French *erreur sur la substance* focus on the error itself. English law, on the other hand, is interested in how the error arose, thus the dichotomy between mistake and misrepresentation: mistake relates to an error which does not result from an inaccurate statement or misrepresentation.[8]

1. Notion and Conditions

Mistake must be shared by both parties (or at least the other party must be aware of it) in English law, while it may be unilateral under Swiss and French law. Therefore, if the seller knows that the work is a forgery, mistake may be invoked in Switzerland and France, but is generally excluded in England. However, misrepresentation may fill that gap, provided i) the mistake was induced by a false statement of the seller, ii) that statement was not merely

8 For a general comparative law study about *mistake*: see Ernst A. Kramer, *Der Irrtum beim Vertragsschluss*, (1998, Zurich).

one of opinion; and iii) the buyer relied on it to enter into the contract.

Mistake as to the authenticity of works of art is inoperative in English law, unless it is the subject-matter of a term in the contract. Here again, an action in misrepresentation may be available. Conversely, Swiss and French law both clearly recognise that mistake can relate to problems of authenticity.

In France, the subject-matter of *erreur sur la substance* is a substantial quality, which is generally defined subjectively; however, the courts have also used an objective approach for the authenticity of works of art. This mixed approach recalls the Swiss *erreur de base*, which relates to facts which are paramount both subjectively and objectively.

Swiss law does not exclude mistakes as to value, in contrast to French and English law; however, this difference is of little relevance for works of art, where a mistake as to value is generally regarded as the consequence of a mistake as to authenticity.

An important difference between the legal systems lies in the extension of the substantial qualities under French law to the possibility to establish authenticity with certainty. The buyer need not prove that the work of art lacks authenticity, as he would in Swiss or English law, but only that there are serious doubts that it is authentic. His position is therefore considerably favoured in France.

Since mistake in French and Swiss law may be unilateral, it is necessary to consider the point of view of the other party. This underlies the French prerequisite that the authenticity must form part of the contractual ambit or the Swiss condition that the seller must be aware of the importance of authenticity for the buyer.

A further cautel is to be found in the notion of inexcusable mistake in French law, which is quite easily attributed to the professional seller. A similar idea lies in the Swiss condition that the buyer must not (or could not reasonably) have been aware that the work of art was not authentic. The buyer's experience is relevant. Conversely, there is little room in English law to regard the professional status of the respective parties and their degree of knowledge.

Finally, the requirement that the work of art be capable of being returned in its original state, which exists in both French and English law, will not be an issue under Swiss law with respect to the nullity of the contract.

2. Consequences

The contract is nullified in France by court order, while a declaration of nullity notified by the mistaken buyer to the seller is sufficient in Switzerland. In England, the courts' intervention is generally not necessary to set the contract aside (except for mistake in equity).

When the requirements of *erreur substantielle* have been met, the French courts have no discretion to refuse to declare the contract void. Conversely, English law is characterised by more flexibility; for instance, in case of negligent or innocent misrepresentation, the courts may declare the contract subsisting and award damages in lieu of rescission. In order to take into account the consequences of the nullity, a negligent buyer may be liable to indemnify the seller in French and Swiss law.

The reimbursement of the purchase price to the buyer follows from the nullity or rescission of the contract under French law or in case of misrepresentation. However, in Swiss law and for the English mistake, recourse to the unjust enrichment provisions is necessary. This might cause difficulties to the buyer in Switzerland, where the limitation period for the reimbursement may have lapsed before the mistake was discovered and the contract nullified. The English system is more coherent: the limitation period for the restitutionary claim only starts running as of the date of the discovery of the mistake (mistake at law) or the court decision (mistake in equity).

The mistaken buyer may not be awarded damages in Switzerland, and generally also in France, unless the seller is in breach of his pre-contractual duty to inform. In English law, mistake would not be a ground for damages. Negligent misrepresentation would entitle the buyer to claim damages and to rescind the contract, while both may not be cumulated in case of innocent misrepresentation.

ii) Dol and Fraudulent Misrepresentation

1. Notion and Conditions

Where the mistake is induced by the fraudulent active or passive behaviour of the seller, in particular where he deceptively is in breach of his duty to inform, *dol* is available in Swiss and French law. However, it is seldom invoked because of the difficulty of proving the seller's deceptive intention. The English equivalent is fraudulent misrepresentation. On one hand, it is narrower than *dol*, because it requires a statement of fact made by the seller. On the other hand, it is broader than *dol*, in that it includes false statements made recklessly.

2. Consequences

The contract entered into under *dol* or because of fraudulent misrepresentation may be nullified or rescinded. Recourse to the courts is necessary only under French law. In all legal systems, damages may be claimed by the deceived buyer.

b) Remedies Regarding the Performance of the Contract

In Swiss and French law, in parallel to the general liability for breach (or non-performance) of contract, there is a special regime for the guarantee against defects in the sales contract. This distinction is unknown to the English legal system, where every contract is treated as containing a guarantee.[9]

The availability of the general means has been excluded by the Swiss Supreme Court on the assumption that the object has been delivered and the contract performed, even if it is a forgery. The situation in France is less certain: the availability of the special regime for cases involving forgeries has recently been questioned.

The possibility of rescinding the contract will depend in all three jurisdictions on whether or not the breach was sufficiently serious. In England, this is characterised by the distinction between condition and warranty. In Switzerland, the courts may refuse to rescind the contract if the defect is not important enough. The courts also have

9 Konrad Zweigert and Hein Kötz, *Introduction to Comparative Law*, (3rd edn, 1998, Oxford) (translated from the German by Tony Weir), p. 503.

discretion in France. Lack of authenticity would be sufficiently serious to justify a rescission of the contract in Switzerland and France, while the English courts would give preference to damages, if anything.

Moreover, unlike Swiss and French law, English law is based on a strict liability for breach of contract. However, this distinction is diminished for the seller's liability for defects: in Switzerland and France, the seller need not have been aware of defects, though the measure of damages is different if he is at fault.

B. EVALUATION

Basically, the buyer's remedies – whether they relate to the formation or the performance of the contract – may lead to the nullity or rescission of the contract and/or to the award of damages. This section focuses on the suitability of these consequences, rather than on the legal requirements of the remedies.

a) Nullity/Rescission of the Contract

The discovery that a work of art is a fake changes the way it is perceived.[10] Therefore, in most cases, the buyer is not interested in keeping the forgery, but wants to set the contract aside, return the work to the seller and get his money back.[11] Conversely, the seller expects the contract to be recognised and enforced.

What weight should be given to the security of transactions in the art market? This is a matter of policy. The inherent uncertainty about authenticity has been expressly regarded by the English and French courts, but has led them to opposite conclusions. The former decided that the principle 'caveat emptor' should apply in the art market,[12] thus favouring the seller, while the latter recognised a special need to protect the buyer, for instance by extending the

10 John Henry Merryman, 'Counterfeit Art' (1992) 1 *International Journal of Cultural Property*, pp. 27-77, at p. 32; Leonard D. DuBoff, Christy O. King and Sally Holt-Caplan, 'Authentification', Booklet K in *The Deskbook of Art Law*, (2nd edn, 1999, New York), p. K-140.

11 It would be unrealistic to ask the seller to deliver him the original work of art, even if it comes in more than one example.

12 The art market could be compared with markets for animals, where a risk is also considered to be inherent.

notion of *erreur substantielle*, or by decreasing the level of proof (serious doubts as to the authenticity).

In our view, the specificities of the art market, in particular the uncertainty and the value inherent in works of art, the high risk of fraud and the frequent inequality between the contracting parties, justify that the legal system should protect a party who has been mistaken about the authenticity, in our hypothesis the buyer, rather than favour security of transactions.

This may also be justified by the following elements. First, the seller is in a position of superiority because he may ascertain better the qualities of the work of art and thus its real value, while the buyer, who is not in possession of the object, only tends to see some aspects of it.[13] Secondly, the seller might still have a claim against the person who sold him the object, whereas the buyer would have no other claim.[14] Thirdly, as Ghestin pointed out, the principle of contractual justice, which is paramount in art transactions, imposes an equivalence of the considerations.[15] Finally, there is a general interest in protecting the art market against forgeries;[16] security of transactions would favour the trade of fakes rather than obstruct it.

Therefore, nullity/rescission of the sales contract is appropriate in the event of forgeries. Security of transactions may be assured through recourse to limitation periods.

b) Damages

An alternative to the nullity/rescission of the contract would be to award damages to the defrauded buyer.

13 Jacques Ghestin, 'Le droit interne français de la vente d'objets d'art et de collection' in Martine Briat (ed.), *International Sales of Works of Art*, (1990, Geneva), pp. 131-156, nn. 8-9.

14 Michael G. Bridge, 'Description, Reliance and the Sale of Goods' (1990) 4 *L.M.C.L.Q.* pp. 455-460, at p. 459.

15 Ghestin, *op. cit.* note 13, n. 8; see also Jean Châtelain, 'L'objet d'art, Objet de collection' in *Etudes offertes à Jacques Flour*, (1979, Paris), pp. 63-94 at p. 80; Jean-Marc Trigeaud, 'L'erreur de l'acheteur, l'authenticité du bien d'art, Etude critique' *RTD civ.* 1982 pp. 55-85, at p. 55.

16 The negative consequences of counterfeits have been summarised as follows: "They are morally offensive; they impair the search of the truth; they skew the allocation of scarce resources; they misrepresent the artist; and they are convenient instruments of fraud" (Merryman, *op. cit.* note 10, at p. 34). In an economic analysis, however, some authors take a view that fakes are rather good (see Bruno S. Frey, *Arts & Economics: Analysis & Cultural Policy*, (2nd edn, 2003, Berlin/Heidelberg/New York), at p. 202 *et seq.*).

Financially, the buyer might not be worse off than if the contract had been set aside. The English perception, which is primarily based on economic considerations, would favour this view. However, by giving priority to nullity/rescission, the general interest may be better served.

Another issue is whether the buyer, once the contract has been set aside, may claim damages (e.g., for the expenditure incurred or lost profits). The existence and measure of damages should depend on whether the seller acted fraudulently or if some kind of fault can be attributed to him. This view seems to be globally adopted in the various legal systems. In any case, the specificities of the art market do not command a special treatment in this respect.

IV. THE PROBLEM OF LIMITATION PERIODS[17]

A. COMPARISON

Limitation periods will in practice direct to a great extent the choice of remedies. In France, where the limitation period is extremely short,[18] it will often be too late for the buyer to invoke the seller's liability for defects, whereas the remedies regarding the formation of the contract might not be time-barred. Similarly, in England, it would be advantageous for the buyer to rely on fraud or mistake at law, where available, since they postpone the limitation period. In Switzerland, it is most likely that the recent extension of the limitation period for claims based on the liability for defects of cultural property will lead the buyer to use the sales provisions rather than those on the *erreur de base*.

A table summarising the limitation periods for each of the buyer's claims in the three jurisdictions may be found below.[19] In brief, with the exception of mistake at law and fraud in England, France used to be by far the most generous jurisdiction with its thirty-year limitation period

17 It is assumed that the seller has not acknowledged the buyer's claim, in which case all three legal systems have specific rules (see in particular art. 135 CO; art. 2248 FCC; s. 29 SGA).

18 See however chapter 3 (French Law), note 68 above.

19 Appendix I, below, pp. 69-70.

for *erreur substantielle* and *dol*, as well as for failure of the duty of delivery. The thirty-year limitation period has now also been adopted in the specific Swiss sales provisions. This legislative change seems to bury – in the context of works of art – the debate created by the *Picasso* case: the defrauded buyer is no longer practically limited by a ten-year period, running from the date of payment, to claim the reimbursement of the purchase price, although he could still nullify the contract for *erreur de base* and *dol* with no limit in time.

It may also be noted that some claims are subject to different limitation periods if the seller acted in good or bad faith (e.g., misrepresentation in England or liability for defects in Switzerland).

Even where English courts would be prepared to award damages, they interpret very strictly the notion of 'reasonable time' during which the buyer may claim rescission; they have repeatedly stressed the importance of security of transactions. This principle is considered in Switzerland and France by the use of absolute limitation periods, which run despite the fact that the innocent party has no knowledge of his cause of action.

B. EVALUATION

There is no doubt that the seller needs to have a certain degree of security that he will not be required to make restitution or pay damages to the defrauded buyer for an unlimited period of time. Otherwise, he would take out special insurances, which would increase prices. Thus, limiting the seller's liability in time would indirectly also favour the buyer and the functioning of the art market itself. Ironically, only the English system allows the buyer, in restricted circumstances (fraud or mistake at law), to act against the seller with no limitation in time.

The length of the limitation periods is the main issue: does it achieve an appropriate balance between the interests of the protagonists? The buyer should have sufficient time to discover that the work is a forgery and benefit from possible evolutions of the experts' opinions and scientific testing.

The limitation periods in the sales provisions of the French, English and, until recently, Swiss legal systems are very

short. They have been designed for goods whose quality may deteriorate over time. With the use of the object, it may be difficult to prove that the defects already existed at the time of the sale and did not only appear afterwards.

Works of art are not affected by such considerations. They differ from other commodities in so far as they are "hopefully lasting forever and ... that any deficiency in quality (i.e., authenticity) cannot be so easily discovered".[20] Moreover, a work of art is authentic or not from the date of its creation. Since lack of authenticity is generally only discovered many years after the purchase, it would be justifiable to subject the claim based on the seller's liability for defects, if one assimilates the lack of authenticity to a defect, to longer limitation periods. This opinion is shared by many scholars.[21] It is exactly the solution which has been adopted by the Swiss Parliament, extending the absolute limitation period from one year to thirty years for claims based on the liability for defects of cultural property. This amendment was justified in particular by reference to the need to protect the art market and to make the seller more cautious in art transactions, as he would be exposed to a claim by the buyer for thirty years.[22]

Differentiated periods according to whether the seller acted fraudulently or not, such as in Swiss law or to some extent in English law, also appear to be desirable.

With longer limitation periods, it is more likely that the perception of authenticity may change. Which perception should prevail? The solution adopted by the French courts in the context of mistake, i.e. the time of the claim (rather than the time of the sale), is sensible, since the late discovery that a work is a forgery is often the consequence of a new perception of its authenticity.

20 Kurt Siehr, 'Art Trade in Fakes, Wrongly Attributed Works of Art and Works of Dubious Provenance' chapter 2 in *International Art Trade and the Law*, Extract from the *Recueil des cours of the Academy of International Law*, volume 243, 1993-VI, pp. 27-55, at p. 28.

21 E.g., Heinrich Honsell in Heinrich Honsell, Nedim Peter Vogt and Wolfgang Wiegand (eds), *Basler Kommentar zum schweizerischen Privatrecht, Obligationenrecht I*, (3rd edn, 2003, Basle/Geneva/Munich), *ad* art. 210 CO, n. 1.

22 Report of the Swiss Government of 21 November 2001 regarding the 1970 UNESCO Convention and the CPTA, *FF* 2002, p. 505 *et seq.* at p. 573.

As a result of short limitation periods in the sales provisions, the buyer may try to rely on the remedies relating to the formation of the contract, or, where available, on the general liability for non-performance. The controversial problem of the relationship between these various remedies arises. The argument that the specific sales provisions should not be circumvented is often set forth. It has been said that the hurdle of the limitation periods should be "solved at source, namely in the law of sales".[23] This wish has now become reality in Switzerland.

23 Zweigert and Kötz, *op. cit.* note 9, at p. 413.

CHAPTER 6

CONCLUSION

The solutions to the four identified issues are similar in the three jurisdictions if the buyer realised or ought to have realised that the work of art was a forgery: they all deny him any kind of protection. However, the risk of forgery is allocated differently where the buyer's belief that the work was authentic is legitimate: Switzerland and France would tend to favour the buyer and England the seller (in the absence of fraud). This reflects the priority given to the protection of consent, in France and Switzerland, and to security of transactions, in England.

In our view, consumers in art are in need of protection. As has been noted, "the law must provide an effective civil remedy to redress the defrauded purchaser".[1]

The particularities of the art market require that special treatment be granted to sales of works of art, which cannot be assimilated to other commodities, such as television sets or cement. The best way to achieve this would be to have a special sales provision.[2]

First, it would anchor a general duty to inform where there is a disparity between the levels of knowledge and expertise of the contracting parties, and where the necessary information about the authenticity cannot be easily accessible.

Secondly, it would define the conditions in which a guarantee of authenticity exists and allocate the risk of forgery, by referring in particular to the existence of initial doubts. It would bring clarity as to the terminology used and weigh the importance of other factors on which the buyer could rely, such as the price or the reputation of the dealer.

1 *Uniform Commercial Code Warranty Solutions to Art Fraud and Forgery*, 14 *Wm. & Mary Law Rev.*, pp. 409-429 (1972-1973), at p. 409.
2 The question remains to what extent this could be dealt with by international instruments rather than on a national level.

Thirdly, it would determine the remedies available to the defrauded buyer, by solving the *aliud/peius* dilemma, as well as the issue of the parallel recourse to remedies relating to the formation of the contract or the general liability in case of non-performance. Priority should be given to the possibility of setting the contract aside, since it also achieves the public interest of protecting the art market against forgeries. The extent of damages should depend on whether the seller acted fraudulently or not. The level of evidence should be lowered by admitting that serious doubts as to the authenticity are sufficient. Finally, authenticity is to be determined at the time of the notice of nullity/rescission, or, in the event of a court decision, at the time of claim (or the judgment).

Last, the new provision would provide for a double limitation period: a short one starting to run from the date of discovery of serious doubts as to the authenticity of the work of art, with a longstop, or absolute limitation period, running from the date of the transaction. The absolute limitation period should be long enough to take into account the frequent late discovery that a work is a forgery, but not compromise unduly the security of transactions; there again, a distinction should be drawn between the fraudulent and the non-fraudulent seller. With respect to the limitation period, the new Swiss provision appears to us to be adequate.

APPENDIX I: TABLE OF LIMITATION PERIODS

A. REMEDIES RELATING TO THE FORMATION OF THE CONTRACT

SWISS LAW	FRENCH LAW	ENGLISH LAW
Erreur / Dol:	***Erreur / Dol:***	**Mistake:**
- <u>Nullity:</u> one year from knowledge (art. 31 CO)	- <u>Nullity / reimbursement of price:</u> five years from discovery (art. 1304 FCC) / 30 years from date of transaction (art. 2262 FCC)	**- at law:** - <u>Rescission:</u> — - <u>Reimbursement of price:</u> six years from discovery of mistake (s. 5 LA) (postponement of limitation period - s. 32(1)(c) LA)
- <u>Reimbursement of price:</u> one year from knowledge / ten years from date of payment (art. 67 CO)		**- in equity:** - <u>Rescission:</u> laches - <u>Reimbursement of price:</u> six years from rescission (s. 5 LA)
- <u>Damages</u> (where available): one year from knowledge / ten years from damage (art. 60 CO)	- <u>Damages</u> (where available): ten years from occurrence of damage or knowledge of damage (art. 2270-1 FCC) / 30 years from date of transaction (art. 2262 FCC)	**Negligent / Innocent Misrepresentation:** - <u>Rescission / reimbursement of price:</u> laches: reasonable time from date of contract - <u>Damages:</u> six years from date of contract (s. 5 LA)
		Fraudulent Misrepresentation: - <u>Rescission:</u> — - <u>Reimbursement of price / damages:</u> six years from discovery of fraud (s. 5 LA) (postponement of limitation period - s. 32(1)(a) LA)

B. REMEDIES RELATING TO THE PERFORMANCE OF THE CONTRACT

SWISS LAW

Non-performance:
ten years from date of transaction (art. 127 CO)

Seller's liability for defects:
- *good faith seller*: one year from discovery of defect; max. 30 years from date of transaction (art. 210(1*bis*) CO)
- *bad faith seller*: 30 years from date of transaction (art. 210(3) and 210(1*bis*) CO)

FRENCH LAW

Non-performance:
30 years from date of transaction (art. 2262 FCC)

Seller's liability for defects:
"à bref délai" (art. 1648 FCC)

ENGLISH LAW

Breach of contract:
<u>Rescission</u> (if 'condition'): reasonable time (acceptance deemed)

<u>Damages</u>:
- *good faith seller*: six years (s. 5 LA)
- *bad faith seller*: six years (s. 5 LA) (postponement of limitation period if action based on fraud - s. 32(1)(a) LA)

APPENDIX II

SOTHEBY'S AUTHENTICITY GUARANTEE

If Sotheby's sells an item which subsequently is shown to be a "counterfeit", subject to the terms below Sotheby's will set aside the sale and refund to the Buyer the total amount paid by the Buyer to Sotheby's for the item, in the currency of the original sale.

For these purposes, "counterfeit" means a lot that in Sotheby's reasonable opinion is an imitation created to deceive as to authorship, origin, date, age, period, culture or source, where the correct description of such matters is not reflected by the description in the catalogue (taking into account any Glossary of Terms). No lot shall be considered a counterfeit by reason only of any damage and/or restoration and/or modification work of any kind (including repainting or over-painting).

Please note that this Guarantee does not apply if either:-

(i) the catalogue description was in accordance with the generally accepted opinions of scholars and experts at the date of the sale, or the catalogue description indicated that there was a conflict of such opinions; or

(ii) the only method of establishing at the date of the sale that the item was a counterfeit would have been by means of processes not then generally available or accepted, unreasonably expensive or impractical to use; or likely to have caused damage to the lot or likely (in Sotheby's reasonable opinion) to have caused loss of value to the lot; or

(iii) there has been no material loss in value of the lot from its value had it been in accordance with its description.

This Guarantee is provided for a period of five (5) years after the date of the relevant auction, is solely for the benefit of the Buyer and may not be transferred to any third party. To be able to claim under this Guarantee, the Buyer must:-

(i) notify Sotheby's in writing within three (3) months of receiving any information that causes the Buyer to question the authenticity or attribution of the item, specifying the lot number, date of the auction at which it was purchased and the reasons why it is thought to be counterfeit; and

(ii) return the item to Sotheby's in the same condition as at the date of the sale to the Buyer and be able to transfer good title in the item, free from any third party claims arising after the date of the sale.

Sotheby's has discretion to waive any of the above requirements. Sotheby's may require the Buyer to obtain at the Buyer's cost the reports of two independent and recognised experts in the field, mutually acceptable to Sotheby's and the Buyer. Sotheby's shall not be bound by any reports produced by the Buyer, and reserves the right to seek additional expert advice at its own expense. In the event Sotheby's decides to rescind the sale under this Guarantee, it may refund to the Buyer the reasonable costs of up to two mutually approved independent expert reports.

SOTHEBY'S UK CONDITIONS OF BUSINESS

(Extracts)

1. Introduction

(a) Sotheby's and Seller's contractual relationship with prospective Buyers is governed by:

(i) these Conditions of Business;

(ii) the Conditions of Business for Sellers displayed in the saleroom and which are available on request;

(iii) Sotheby's Authenticity Guarantee as printed in the sale catalogue; and

(iv) any additional notices and terms printed in the sale catalogue, in each case as amended by any saleroom notice or auctioneer's announcement at the auction.

(b) As auctioneer, Sotheby's acts as agent for the Seller. A sale contract is made directly between the Seller and the Buyer. ...

2. Common Terms

...

"Counterfeit" is as defined in Sotheby's Authenticity Guarantee;

...

3. Duties of Bidders and of Sotheby's in respect of items for sale

...

(b) Each lot offered for sale at Sotheby's is available for inspection by the Bidders prior to the sale. Sotheby's accepts bids on lots solely on the basis that Bidders (and independent experts on their behalf, to the extent appropriate given the nature and value of the lot and the Bidder's own expertise) have fully inspected the lot prior to bidding and have satisfied themselves as to both the condition of the lot and the accuracy of its description.

...

(d) Information provided to Bidders in respect of any lot, including any estimate, whether written or oral and including information in any catalogue, condition or other report, commentary or valuation, is not a representation of fact but rather is a statement of opinion genuinely held by Sotheby's. ...

...

4. Exclusions and limitations of liability to Buyers

(a) Sotheby's shall refund the Purchase Price to the Buyer in circumstances where it deems that the lot is a Counterfeit and each of the conditions of the Authenticity Guarantee has been satisfied.

...

APPENDIX III

CHRISTIE'S CONDITIONS OF SALE

(Extracts)

1. Christie's As Agent
Except as otherwise stated Christie's acts as agent for the seller. The contract for the sale of the property is therefore made between the seller and the buyer.

2. Before The Sale
(a) Examination of property
Prospective buyers are strongly advised to examine personally any property in which they are interested, before the auction takes place. Condition reports are usually available on request. Neither Christie's nor the seller provides any guarantee in relation to the nature of the property apart from the Limited Warranty in paragraph 6 below. THE PROPERTY IS OTHERWISE SOLD "AS IS".

(b) Catalogue and other descriptions
... All statements by us in the catalogue entry for the property or in the condition report, or made orally or in writing elsewhere, are statements of opinion and are not to be relied on as statements of fact. Such statements do not constitute a representation, warranty or assumption of liability by us of any kind. ...

(c) Buyer's responsibility
Except as stated in the Limited Warranty in paragraph 6 below, all property is sold "AS IS" without any representation or warranty of any kind by Christie's or the seller. Buyers are responsible for satisfying themselves concerning the condition of the property and the matters referred to in the catalogue entry.

5. Extent of Christie's Liability
We agree to refund the purchase price in the circumstances of the Limited Warranty set out in paragraph 6 below. Apart from that, neither the seller nor we, nor any of our offices, employees or agents, are responsible for the correctness of any statement of whatever kind concerning any lot, whether written or oral, nor for any other errors or

omissions in description or for any faults or defects in any lot. Except as stated in paragraph 6 below, neither the seller, ourselves, our officers, employees or agents, give any representation, warranty or guarantee or assume any liability of any kind in respect of any lot with regard to merchantability, fitness for a particular purpose, description, size, quality, condition, attribution, authenticity, rarity, importance, medium, provenance, exhibition history, literature or historical relevance. Except as required by local law any warranty of any kind whatsoever is excluded by this paragraph.

6. Limited Warranty
Subject to the terms and conditions of this paragraph, Christie's warrants for a period of five years from the date of the sale that any property described in headings printed in UPPER CASE TYPE (i.e. headings having all capital-letter type) in this catalogue (as such description may be amended by any saleroom notice or announcement) which is stated without qualification to be the work of a named author or authorship, is authentic and not a forgery. The term "author" or "authorship" refers to the creator of the property or to the period, culture, source or origin, as the case may be, with which the creation of such property is identified in the UPPER CASE description of the property in this catalogue. Only the UPPER CASE TYPE headings of lots in this catalogue indicate what is being warranted by Christie's. Christie's warranty does not apply to supplemental material which appears below the UPPER CASE TYPE headings of each lot and Christie's is not responsible for any errors or omissions in such material. The terms used in the headings are further explained in Important Notices and Explanation of Cataloguing Practice. The warranty does not apply to any heading which is stated to represent a qualified opinion. The warranty is subject to the following:

(i) It does not apply where (a) the catalogue description or saleroom notice corresponded to the generally accepted opinion of scholars or experts at the date of the sale or fairly indicated that there was a conflict of opinions; or (b) correct identification of a lot can be demonstrated only by means of either a scientific

process not generally accepted for use until after publication of the catalogue or a process which at the date of publication of the catalogue was unreasonably expensive or impractical or likely to have caused damage to the property.

(ii) The benefits of the warranty are not assignable and shall apply only to the original buyer of the lot as shown on the invoice originally issued by Christie's when the lot was sold at auction.

(iii) The original buyer must have remained the owner of the lot without disposing of any interest in it to any third party.

(iv) The buyer's sole and exclusive remedy against Christie's and the seller, in place of any other remedy which might be available, is the cancellation of the sale and the refund of the original purchase price paid for the lot. Neither Christie's nor the seller will be liable for any special, incidental or consequential damages including, without limitation, loss of profits nor for interest.

(v) The buyer must give written notice of claim to us within five years from the date of the auction. It is Christie's general policy, and Christie's shall have the right, to require the buyer to obtain the written opinions of two recognised experts in the field, mutually acceptable to Christie's and to the buyer, before Christie's decides whether or not to cancel the sale under the warranty.

(vi) The buyer must return the lot to the Christie's saleroom at which it was purchased in the same condition as at the time of the sale.

APPENDIX IV

ENGLISH TRANSLATION OF THE
RELEVANT SWISS PROVISIONS

CIVIL CODE*

Art. 2

B. Limits of Civil Rights
I. Misuse of a right

1. Every person is bound to exercise his rights and fulfil his obligations according to the principles of good faith.

2. The law does not sanction the evident abuse of a person's rights.

CODE OF OBLIGATIONS ('CO')†

FIRST DIVISION: GENERAL PROVISIONS
FIRST TITLE: ORIGIN OF OBLIGATIONS

First Chapter: Originating from Contract

Art. 23

F. Defects of the contract's conclusion
I. Error
1. Effect

A person acting under material error at the conclusion of a contract is not bound by it.

Art. 24

2. Cases of error

1. An error is in particular deemed to be material in the following cases:

1) ...

2) if the party in error had another thing in mind than the one which is the object expressed in the contract

...

* Translation of the *Code Civil* of 10 December 1907 by Ivy Williams, Siegfried Wyler and Barbara Wyler, *The Swiss Civil Code, English Version*, (1987, Zurich). A different terminology has been used in this paper. The official text is available on: http://www.admin.ch/ch/f/rs/c210.html (French version), http://www.admin.ch/ch/d/sr/c210.html (German version), http://www.admin.ch/ch/i/rs/c210.html (Italian version) (accessed on 30 June 2005).

† Translation of the *Code des Obligations* of 30 March 1911 by the Swiss-American Chamber of Commerce, *Swiss Code of Obligations, English Translation of the Official Text*, (3rd edn, 1995, Zurich), with the exception of Art. 210(1*bis*). A different terminology has been used in this paper. The official text is available on: http://www.admin.ch/ch/f/rs/c220.html (French version), http://www.admin.ch/ch/d/sr/c220.html (German version), http://www.admin.ch/ch/i/rs/c220.html (Italian version) (accessed on 30 June 2005).

3) ...

4) if the error related to certain facts which the party in error, in accordance with the rules of good faith in the course of business, considered to be a necessary basis of the contract.

2. Where, on the other hand, the error affected only the motives for entering into the contract, it is not considered to be material.

3. ...

3. Action contrary to good faith

Art. 25

1. A party is not permitted to avail himself of the error if this is contrary to good faith.

2. In particular, a party in error is bound by a contract as it was understood by him, as soon as the other party consents thereto.

4. Negligent error

Art. 26

1. If a party declares his intention not to be bound by the contract due to error attributable to his own negligence, he is bound to make compensation for the damage resulting from his rescission of the contract, unless the other party knew or should have known of such error.

2. Where equity so requires, the judge may award compensation for further damages.

II. Wilful deception

Art. 28

1. If a party has been induced to enter into a contract by the wilful deception of the other party, the contract shall not bind the deceived party even if the error so induced was not material.

2. ...

IV. Waiver of defect by ratification of contract

Art. 31

1. If the party influenced by the error, deception, or duress, within one year, neither declares to the other party that he is not bound by the contract nor demands restitution, then the contract is deemed to be ratified.

2. Such period runs, in the event of error or deception, from the time of its discovery and, in the event of a threat, from the time of its removal.

3. Ratification of a contract which, due to deception or threat was voidable, does not itself bar a claim for damages.

Second Chapter: Originating from Tort

Art. 41

1. Whoever unlawfully causes damage to another, whether wilfully or negligently shall be liable for damages.

2. ...

A. Liability in general

I. Prerequisites for liability

Art. 60

1. The claim for damages or reparations is barred by the statute of limitations after one year from the date when the damaged person has received knowledge of the damage and of the identity of the person who is liable, but, in any event, after ten years from the date the act causing the damage took place.

2. ...

3. ...

F. Statute of limitations

Third Chapter: Originating from Unjust Enrichment

Art. 62

1. Whoever has been unjustly enriched out of another person's property shall make restitution of such enrichment.

2. In particular, this obligation shall arise if a person has received something without any valid reason, or for a reason which did not materialize, or which subsequently ceased to exist.

A. Prerequisite

I. In general

Art. 67

1. A claim of unjust enrichment is barred one year after the injured person knew of his claim, but, in any event, ten years after the claim arose.

2. ...

D. Statute of limitations

SECOND TITLE: EFFECT OF OBLIGATIONS

Second Chapter: Consequences of Non-performance

Art. 97

1. If the performance of an obligation can not at all or not duly be effected, the obligor shall compensate for the damage arising therefrom, unless he proves that no fault at all is attributable to him.

2. ...

A. Non-performance

I. Obligation to compensate by the obligor

1. In general

B. Default of the obligor

I. Conditions

Art. 102

1. If an obligation is due, the obligor will be in default upon being reminded thereof by the obligee.

2. If a certain due date was agreed upon performance, or if such a date arises from a stipulated and duly exercised notice of termination, the obligor will already be in default upon the expiration of such date.

II. Effect

4. Withdrawal from contract and damages

a. Fixing a time limit

Art. 107

1. If the obligor is in default in the case of a bilateral contract, the obligee shall be entitled to fix an appropriate time limit for subsequent performance, or to have it fixed by the competent authority.

2. If, at the expiration of this time limit, there is no performance, the obligee may still sue for performance plus damages due to delay. Alternatively, if he so declares without delay, he may waive subsequent performance and ask for compensation for damages arising out of the non-performance or withdraw from the contract.

b. Without fixing a time limit

Art. 108

The fixing of a time limit for subsequent performance is not required:

1) if the behaviour of the obligor indicates that this would be in vain, or

2) if, because of the delay of the obligor, performance has become useless to the obligee, or

3) if the contract indicates that it was the intention of the parties that performance was to be made exactly at a defined time, or prior to the end of an exactly defined time period.

e. Effect of the withdrawal

Art. 109

1. A party who withdraws from a contract may refuse the promised consideration and reclaim whatever he has already performed.

2. Moreover, he has a claim for compensation for damages arising out of the withdrawal from the contract, unless the obligor proves that no fault at all is attributable to him.

Third Title: Extinction of Obligations

Art. 127
After ten years, all claims for which the federal civil law does not provide otherwise are barred by the statute of limitations.

G. Statute of limitations
I. Time periods
1. Ten years

SECOND DIVISION: THE INDIVIDUAL TYPES OF CONTRACTS
Sixth title: Purchase and Barter

First Chapter: General Provisions

Art. 184
1. A contract of purchase is a contract whereby the seller obligates himself to deliver to the buyer the object of the purchase and to transfer title thereto to the buyer, and the buyer obligates himself him to pay the purchase price to the seller.

2. Unless there exists an agreement or custom to the contrary, both the seller and the buyer are obligated to perform simultaneously – performance for performance.

3. The price is sufficiently determined if it is determinable from the circumstances.

A. Rights and obligations in general

Second Chapter: Purchase of Personal Property

Art. 197
1. The seller is liable to the buyer for express representations made and that the object of the purchase has no physical or legal defects which eliminate or substantially reduce its value or its fitness for the intended use.

2. The seller is liable even if he did not know of the defects.

B. Obligations of the seller.
III. Warranty against defects in the object of the purchase
1. Object of warranty
a. In general

Art. 200
1. The seller is not liable for defects of which the buyer had knowledge at the time of the purchase.

2. For defects which the buyer, applying normal attention, should have known, the seller is only liable if he has assured the buyer of their non-existence.

3. Defects known to the buyer

Art. 201
1. The buyer shall examine the quality of the object of the purchase received as soon as it is customary in accordance with usual business practice, and

4. Notification of defects
a. In general

shall immediately notify the seller in the event that defects exist for which the seller must warrant.

2. If the buyer fails to so notify, the object purchased is deemed to have been accepted to the extent that there are no defects involved which were not recognizable in the course of a customary examination.

3. If defects are discovered at a later date, notification must be given immediately upon their discovery. Otherwise the object of the purchase is deemed to have been accepted with respect to such defects.

5. Wilful deception

Art. 203

If the buyer is wilfully deceived by the seller, an omission of notification by the buyer shall not limit the warranty.

7. Content of the buyer's action

a. Action for rescission or reduction of purchase price

Art. 205

1. In the case of warranty against defects in the object of the purchase, the buyer may either elect to sue for rescission of the purchase contract, or to sue for reduction of the purchase price, in order to be compensated for the reduction in value of the object of the purchase.

2. Even if an action for rescission has been initiated, the judge is free to adjudge compensation for the reduction in value only provided that the circumstances do not justify a rescission of the purchase contract.

3. If the reduction in value claimed equals the purchase price, then the buyer can only demand rescission.

8. Execution of rescission

a. In general

Art. 208

1. In the case of rescission of a purchase, the buyer must return to the seller the object of the purchase, together with any benefits collected in the meantime.

2. The seller must repay the purchase price paid, including interest and, in addition, in compliance with the rules relating to complete deprivation, compensate the buyer for costs of litigation, disbursements, as well as for such damage as has been directly caused to the buyer as a result of the delivery of the defective goods.

3. The seller is obligated to compensate for further damage unless he proves that no fault at all is attributable to him.

Art. 210

1. Actions based on a warranty for defects in the object of the purchase shall be barred at the end of one year after delivery to the buyer of the object sold, even if the defect was only discovered by the buyer at a later date, unless the seller has assumed the liability for a longer period.

1*bis.* For cultural property in the sense of article 2(1) of the Federal Act on the International Transfer of Cultural Property, the claim is barred by the statute of limitations after one year from the date when the buyer has discovered the defects; in any event, it is barred after 30 years from the date that the contract was concluded.

2. Objections made by the buyer based on existing defects remain valid if the required notice has been given to the seller within one year after delivery.

3. The statute of limitations of one year may not be invoked by the seller if it can be proven that he wilfully deceived the buyer.

FEDERAL ACT ON THE INTERNATIONAL TRANSFER OF CULTURAL PROPERTY ('CPTA')*

Art. 2(1)

'Cultural property' means property which, on religious or secular grounds, is significant for archaeology, prehistory, history, literature, art or science and which belongs to one of the categories stated in article 1 of the 1970 UNESCO Convention.

UNESCO CONVENTION ON THE MEANS OF PROHIBITING AND PREVENTING THE ILLICIT IMPORT, EXPORT AND TRANSFER OF OWNERSHIP OF CULTURAL PROPERTY

(done at Paris, 14 November 1970)

Art. 1

For the purposes of this Convention, the term 'cultural property' means property which, on religious or secular grounds, is specifically designated by each State as being of importance for archaeology, prehistory, history, literature, art or science and which belongs to

* Free translation of the *Loi fédérale sur le transfert international des biens culturels* of 20 June 2003.

the following categories:

a. rare collections and specimens of fauna, flora, minerals and anatomy, and objects of palaeontological interest;

b. property relating to history, including the history of science and technology and military and social history, to the life of national leaders, thinkers, scientists and artists and to events of national importance;

c. products of archaeological excavations (including regular and clandestine) or of archaeological discoveries;

d. elements of artistic or historical monuments or archaeological sites which have been dismembered;

e. antiquities more than one hundred years old, such as inscriptions, coins and engraved seals;

f. objects of ethnological interest;

g. property of artistic interest, such as:

 i. pictures, paintings and drawings produced entirely by hand on any support and in any material (excluding industrial designs and manufactured articles decorated by hand);

 ii. original works of statuary art and sculpture in any material;

 iii. original engravings, prints and lithographs;

 iv. original artistic assemblages and montages in any material;

h. rare manuscripts and incunabula, old books, documents and publications of special interest (historical, artistic, scientific, literary, etc.) singly or in collections;

i. postage, revenue and similar stamps, singly or in collections;

j. archives, including sound, photographic and cinematographic archives;

k. articles of furniture more than one hundred years old and old musical instruments.

APPENDIX V

ENGLISH TRANSLATION OF THE RELEVANT PROVISIONS OF THE FRENCH CIVIL CODE ('FCC') *

BOOK III
OF THE VARIOUS WAYS HOW OWNERSHIP IS ACQUIRED
TITLE III
Of Contracts or of Conventional Obligations in General

Chapter II - Of the Essential Requisites for the Validity of Agreements
Section I - Of Consent

Art. 1109

There is no valid consent, where the consent was given only by error, or where it was extorted by duress or abused by deception.

Art. 1110

Error is a ground for annulment of an agreement only where it rests on the very substance of the thing which is the object thereof.

It is not a ground for annulment where it only rests on the person with whom one has the intention of contracting, unless regard to/ for that person was the main *cause* of the agreement.

Art. 1116

Deception is a ground for annulment of a contract where the schemes used by one of the parties are such that it is obvious that, without them, the other party would not have entered into the contract.

It may not be presumed, and must be proved.

Art. 1117

An agreement entered into by error, duress or deception is not void by operation of law; it only gives rise to an action for annulment or rescission, in the cases and in the manner explained in Section VII of Chapter V of this Title.

* Translation of the *Code Civil* of 21 March 1804 by Georges Rouhette, Professor of Law of the University of Clermont-Ferrand I, with the assistance of Anne Berton, Research Assistant in English: http://www.legifrance.gouv.fr/html/codes_traduits/code_civil_textA.htm (accessed on 30 June 2005). The official text is available on: http://www.legifrance.gouv.fr/html/index.html.

Chapter III - Of the Effect of Obligations

*Section IV - Of Damages Resulting from
the Non-Performance of Obligations*

Art. 1150

A debtor is liable only for damages which were foreseen or which could have been foreseen at the time of the contract, where it is not through his own intentional breach that the obligation is not fulfilled.

Art. 1151

Even in the case where the non-performance of the agreement is due to the debtor's intentional breach, damages may include, with respect to the loss suffered by the creditor and the profit which he has been deprived of, only what is an immediate and direct consequence of the non-performance of the agreement.

Chapter IV - Of the Various Kinds of Obligations

Section I - Of Conditional Obligations

§ 3 - Of Condition Subsequent

Art. 1184

A condition subsequent is always implied in synallagmatic contracts, for the case where one of the two parties does not carry out his undertaking.

In that case, the contract is not avoided as of right. The party towards whom the undertaking has not been fulfilled has the choice either to compel the other to fulfil the agreement when it is possible, or to request its avoidance with damages.

Avoidance must be applied for in court, and the defendant may be granted time according to circumstances.

Chapter V - Of the Extinguishment of Obligations

*Section VII - Of the Action for Annulment or
Rescission of Agreements*

Art. 1304

In all cases where an action for annulment or rescission of an agreement is not limited to a shorter time by a special statute, that action lasts five years.

In case of duress, that time runs only from the day when it has ceased; in case of error or deception, from the day when they were discovered.

…

TITLE IV

Of Undertakings Formed Without an Agreement
Chapter II - Of Intentional and Unintentional Wrongs
[Of Torts]

Art. 1382

Any act whatever of man, which causes damage to another, obliges the one by whose fault it occurred, to compensate it.

Art. 1383

Everyone is liable for the damage he causes not only by his intentional act, but also by his negligent conduct or by his imprudence.

TITLE VI

Of Sales
Chapter IV - Of the Obligations of the Seller

Section I – General Provisions

Art. 1603

He has two main obligations, that to deliver and that to warrant the thing which he sells.

Section II - Of Delivery

Art. 1604

Delivery is the transfer of the thing sold into the power and possession of the buyer.

Section III - Of Warranty

§ 2 - Of Warranty against the Defects of the Thing Sold

Art. 1641

A seller is bound to a warranty on account of the latent defects of the thing sold which render it unfit for the use for which it was intended, or which so impair that use that the buyer would not have acquired it, or would only have given a lesser price for it, had he known of them.

Art. 1642

A seller is not liable for defects which are patent and which the buyer could ascertain for himself.

Art. 1643

He is liable for latent defects, even though he did not know of them, unless he has stipulated that he would not be bound to any warranty in that case.

Art. 1644

In the cases of Articles 1641 and 1643, the buyer has the choice either of returning the thing and having the price repaid to him or of keeping the thing and having a part of the price repaid to him, as appraised by experts.

Art. 1645

Where the seller knew of the defects of the thing, he is liable, in addition to restitution of the price which he received from him, for all damages towards the buyer.

Art. 1646

Where the seller did not know of the defects of the thing, he is only liable for restitution of the price and for reimbursing the buyer for the costs occasioned by the sale.

Art. 1648

The action resulting from redhibitory vices must be brought by the buyer within a short time, according to the nature of the redhibitory vices and the usage of the place where the sale was made.

...

TITLE XX

Of Prescription and of Possession

Chapter V - Of the Time Required to Prescribe

Section II - Of Thirty-Year Prescription

Art. 2262

All actions, *in rem* as well as *in personam*, are prescribed by thirty years, without the person who alleges that prescription being obliged to adduce a title, or a plea resulting from bad faith being allowed to be set up against him.

Art. 2270-1

Actions for tort liability are barred after ten years from the manifestation of the injury or of its aggravation.

...

DÉCRET N° 81-255 DU 3 MARS 1981[*]

DÉCRET SUR LA RÉPRESSION DES FRAUDES EN MATIÈRE DE TRANSACTIONS D'OEUVRES D'ART ET D'OBJETS DE COLLECTION

Article 1[†]

Les vendeurs habituels ou occasionnels d'oeuvres d'art ou d'objets de collection ou leurs mandataires, ainsi que les officiers publics ou ministériels et les personnes habilitées procédant à une vente publique aux enchères doivent, si l'acquéreur le demande, lui délivrer une facture, quittance, bordereau de vente ou extrait du procès-verbal de la vente publique contenant les spécifications qu'ils auront avancées quant à la nature, la composition, l'origine et l'ancienneté de la chose vendue.

Article 2

La dénomination d'une oeuvre ou d'un objet, lorsqu'elle est uniquement et immédiatement suivie de la référence à une période historique, un siècle ou une époque, garantit l'acheteur que cette oeuvre ou objet a été effectivement produit au cours de la période de référence.

Lorsqu'une ou plusieurs parties de l'oeuvre ou objet sont de fabrication postérieure, l'acquéreur doit en être informé.

Article 3

A moins qu'elle ne soit accompagnée d'une réserve expresse sur l'authenticité, l'indication qu'une oeuvre ou un objet porte la signature ou l'estampille d'un artiste entraîne la garantie que l'artiste mentionné en est effectivement l'auteur.

Le même effet s'attache à l'emploi du terme «par» ou «de» suivie de la désignation de l'auteur.

Il en va de même lorsque le nom de l'artiste est immédiatement suivi de la désignation ou du titre de l'oeuvre.

Article 4

L'emploi du terme «attribué à» suivi d'un nom d'artiste garantit que l'oeuvre ou l'objet a été exécuté pendant la période de production de l'artiste mentionné et que des présomptions sérieuses désignent celui-ci comme l'auteur vraisemblable.

[*] Available on: http://www.legifrance.gouv.fr/texteconsolide/ADHUM.htm (accessed on 30 June 2005).

[†] *Modifié par Décret 2001-650 2001-07-19 art. 69 JORF 21 juillet 2001 en vigueur le 1er octobre 2001.*

Article 5

L'emploi des termes «atelier de» suivis d'un nom d'artiste garantit que l'oeuvre a été exécutée dans l'atelier du maître cité ou sous sa direction.

La mention d'un atelier est obligatoirement suivie d'une indication d'époque dans le cas d'un atelier familial ayant conservé le même nom sur plusieurs générations.

Article 6

L'emploi des termes «école de» suivis d'un nom d'artiste entraîne la garantie que l'auteur de l'oeuvre a été l'élève du maître cité, a notoirement subi son influence ou bénéficié de sa technique. Ces termes ne peuvent s'appliquer qu'à une oeuvre exécutée du vivant de l'artiste ou dans un délai inférieur à cinquante ans après sa mort.

Lorsqu'il se réfère à un lieu précis, l'emploi du terme «école de» garantit que l'oeuvre a été exécutée pendant la durée d'existence du mouvement artistique désigné, dont l'époque doit être précisée et par un artiste ayant participé à ce mouvement.

Article 7

Les expressions «dans le goût de», «style», «manière de», «genre de», «d'après», «façon de», ne confèrent aucune garantie particulière d'identité d'artiste, de date de l'oeuvre, ou d'école.

Article 8

Tout fac-similé, surmoulage, copie ou autre reproduction d'une oeuvre d'art ou d'un objet de collection doit être désigné comme tel.

Article 9

Tout fac-similé, surmoulage, copie ou autre reproduction d'une oeuvre d'art originale au sens de l'article 71 de l'annexe III du code général des impôts, exécuté postérieurement à la date d'entrée en vigueur du présent décret, doit porter de manière visible et indélébile la mention «Reproduction».

Article 10

Quiconque aura contrevenu aux dispositions des articles 1er et 9 du présent décret sera passible des amendes prévues pour les contraventions de la cinquième classe.

DECREE ON THE REPRESSION OF FRAUD IN THE CASE OF TRANSACTIONS IN WORKS OF ART OR ITEMS FROM COLLECTIONS

Decree No. 81-225 of 3rd March 1981*

Article 1†

Dealers whether regular or occasional, in works of art and items from collections, (and their agents), together with public officers, notaries and persons empowered to conduct a public auction must, if the purchaser so requests, issue him with an invoice, receipt, consignment note or extract from the official report of the public sale containing the specifications put forward with regard to the nature, composition, origin and age of the object sold.

Article 2

The designation of a work of art or an object, where this is solely and immediately followed by a reference to an historical period, century or era, guarantees to the buyer that this work or object was in fact produced during the period referred to.

Where one or more parts of the work or object are of a later date, the buyer must be informed of this fact.

Article 3

Unless it is accompanied by an express reservation as to authenticity, an indication that a work or an object bears the signature or stamp of an artist gives rise to a guarantee that the artist mentioned is in fact the author of the work.

The same applies where the terms "by" or "of" are used, followed by the author's name.

The same applies where the name of the artist is immediately followed by the designation or the title of the work.

Article 4

The use of the term "attributed to" followed by the name of an artist guarantees that the work or object was produced during the working life of the named artist and that there is serious presumptive evidence indicating that that artist is the probable author of the work.

Article 5

The use of the words "studio of" followed by the name of an artist guarantees that the work was produced in the studio of the master named or under his direction.

* Translation: Ruth Redmond-Cooper, Institute of Art and Law.

† *Modified by Decree 2001-650 2001-07-19 art. 69 JORF 21 July 2001, entered into force on 1 October 2001.*

The mention of a studio shall be followed by an indication of the historical period in the case of a family studio which bore the same name over several generations.

Article 6

The use of the words "school of" followed by the name of an artist gives rise to a guarantee that the author of the work was the pupil of the master in question, was known to have come under his influence or benefited from his technique. These terms can apply only to a work produced during the lifetime of the artist or within a period of fifty years or less following his death.

Where it refers to a specific place, the use of the words "school of" guarantee that the work was produced during the period of existence of the artistic movement in question, whose dates must be specified, and by an artist who was part of that movement.

Article 7

The expressions "in the style of", "manner of", "genre of", "after", "fashion of" do not bestow any specific guarantee as to the identity of the artist, the date of the work or the school.

Article 8

Any facsimile, cast, copy or other reproduction of a work of art or of an object from a collection must be indicated as such.

Article 9

Any facsimile, cast, copy or other reproduction of an original work of art within the meaning of article 71 of annex III of the general code of taxation, produced date of entry into force of this decree, should be endorsed in a visible and indelible manner with the word "Reproduction".

Article 10

Any person who is in breach of the provisions contained in articles 1 and 9 of this decree will be liable to a fine as laid down for contraventions of the fifth class.

(2) Where the seller sells goods in the course of a business, there is an implied term that the goods supplied under the contract are of satisfactory quality.

(2A) For the purposes of this Act, goods are of satisfactory quality if they meet the standard that a reasonable person would regard as satisfactory, taking account of any description of the goods, the price (if relevant) and all the other relevant circumstances.

(2B) For the purposes of this Act, the quality of goods includes their state and condition and the following (among others) are in appropriate cases aspects of the quality of goods—

(a) fitness for all the purposes for which goods of the kind in question are commonly supplied,

(b) appearance and finish,

(c) freedom from minor defects,

(d) safety, and

(e) durability.

(2C) The term implied by subsection (2) above does not extend to any matter making the quality of goods unsatisfactory—

(a) which is specifically drawn to the buyer's attention before the contract is made,

(b) where the buyer examines the goods before the contract is made, which that examination ought to reveal, or

(c) in the case of a contract for sale by sample, which would have been apparent on a reasonable examination of the sample.

(2D) If the buyer deals as consumer or, in Scotland, if a contract of sale is a consumer contract, the relevant circumstances mentioned in subsection (2A) above include any public statements on the specific characteristics of the goods made about them by the seller, the producer or his representative, particularly in advertising or on labelling.

(2E) A public statement is not by virtue of subsection (2D) above a relevant circumstance for the purposes of subsection (2A) above in the case of a contract of sale, if the seller shows that—

(a) at the time the contract was made, he was not, and could not reasonably have been, aware of the statement,

(b) before the contract was made, the statement had been withdrawn in public or, to the extent that it contained anything which was incorrect or misleading, it had been corrected in public, or

(c) the decision to buy the goods could not have been influenced by the statement.

APPENDIX VII

Relevant Provisions of English Law

SALE OF GOODS ACT 1979 ('SGA')*

Part II - Formation of the Contract

S. 11. When condition to be treated as warranty

...

(3) Whether a stipulation in a contract of sale is a condition, the breach of which may give rise to a right to treat the contract as repudiated, or a warranty, the breach of which may give rise to a claim for damages but not to a right to reject the goods and treat the contract as repudiated, depends in each case on the construction of the contract; and a stipulation may be a condition, though called a warranty in the contract.

(4) Subject to section 35A below where a contract of sale is not severable and the buyer has accepted the goods or part of them, the breach of a condition to be fulfilled by the seller can only be treated as a breach of warranty, and not as a ground for rejecting the goods and treating the contract as repudiated, unless there is an express or implied term of the contract to that effect.

...

S. 13. Sale by description
(1) Where there is a contract for the sale of goods by description, there is an implied term that the goods will correspond with the description.

(1A) As regards England and Wales and Northern Ireland, the term implied by subsection (l) above is a condition.

...

(3) A sale of goods is not prevented from being a sale by description by reason only that, being exposed for sale or hire, they are selected by the buyer.

...

S. 14. Implied terms about quality or fitness
(1) Except as provided by this section and section 15 below and subject to any other enactment, there is no implied term about the quality or fitness for any particular purpose of goods supplied under a contract of sale.

* As amended in particular by Sale and Supply of Goods Act 1994 (c.35) and Sale and Supply of Goods to Consumers Regulation 2002.

(2F) Subsections (2D) and (2E) above do not prevent any public statement from being a relevant circumstance for the purposes of subsection (2A) above (whether or not the buyer deals as consumer or, in Scotland, whether or not the contract of sale is a consumer contract) if the statement would have been such a circumstance apart from those subsections.

(3) Where the seller sells goods in the course of a business and the buyer, expressly or by implication, makes known—

(a) to the seller, or

(b) where the purchase price or part of it is payable by instalments and the goods were previously sold by a credit-broker to the seller, to that credit-broker,

any particular purpose for which the goods are being bought, there is an implied term that the goods supplied under the contract are reasonably fit for that purpose, whether or not that is a purpose for which such goods are commonly supplied, except where the circumstances show that the buyer does not rely, or that it is unreasonable for him to rely, on the skill or judgment of the seller or credit-broker.

(4) An implied term about quality or fitness for a particular purpose may be annexed to a contract of sale by usage.

(5) The preceding provisions of this section apply to a sale by a person who in the course of a business is acting as agent for another as they apply to a sale by a principal in the course of a business, except where that other is not selling in the course of a business and either the buyer knows that fact or reasonable steps are taken to bring it to the notice of the buyer before the contract is made.

(6) As regards England and Wales and Northern Ireland, the terms implied by subsections (2) and (3) above are conditions.

...

PART IV - PERFORMANCE OF THE CONTRACT

S. 34. Buyer's right of examining the goods
Unless otherwise agreed, when the seller tenders delivery of goods to the buyer, he is bound on request to afford the buyer a reasonable opportunity of examining the goods for the purpose of ascertaining whether they are in conformity with the contract [...].

S. 35. Acceptance
(1) The buyer is deemed to have accepted the goods subject to subsection (2) below—

(a) when he intimates to the seller that he has accepted them, or

(b) when the goods have been delivered to him and he does any act in relation to them which is inconsistent with the ownership of the seller.

(2) Where goods are delivered to the buyer, and he has not previously examined them, he is not deemed to have accepted them under subsection (1) above until he has had a reasonable opportunity of examining them for the purpose—

(a) of ascertaining whether they are in conformity with the contract, and

(b) in the case of a contract for sale by sample, of comparing the bulk with the sample.

(3) Where the buyer deals as consumer or (in Scotland) the contract of sale is a consumer contract, the buyer cannot lose his right to rely on subsection (2) above by agreement, waiver or otherwise.

(4) The buyer is also deemed to have accepted the goods when after the lapse of a reasonable time he retains the goods without intimating to the seller that he has rejected them.

(5) The questions that are material in determining for the purposes of subsection (4) above whether a reasonable time has elapsed include whether the buyer has had a reasonable opportunity of examining the goods for the purpose mentioned in subsection (2) above.

...

PART VA - ADDITIONAL RIGHTS OF BUYER IN CONSUMER CASES

S. 48A. Introductory

(1) This section applies if—

(a) the buyer deals as consumer or, in Scotland, there is a consumer contract in which the buyer is a consumer, and

(b) the goods do not conform to the contract of sale at the time of delivery.

(2) If this section applies, the buyer has the right—

(a) under and in accordance with section 48B below, to require the seller to repair or replace the goods, or

(b) under and in accordance with section 48C below—

(i) to require the seller to reduce the purchase price of the goods to the buyer by an appropriate amount, or

(ii) to rescind the contract with regard to the goods in question.

(3) For the purposes of subsection (1)(b) above goods which do not conform to the contract of sale at any time within the period of six months starting with the date on which the goods were delivered to the buyer must be taken not to have so conformed at that date.

(4) Subsection (3) above does not apply if—

(a) it is established that the goods did so conform at that date;

(b) its application is incompatible with the nature of the goods or the nature of the lack of conformity.

S. 48C. Reduction of purchase price or rescission of contract
(1) If section 48A above applies, the buyer may—

(a) require the seller to reduce the purchase price of the goods in question to the buyer by an appropriate amount, or

(b) rescind the contract with regard to those goods,

if the condition in subsection (2) below is satisfied.

(2) The condition is that—

(a) by virtue of section 48B(3) above the buyer may require neither repair nor replacement of the goods; or

(b) the buyer has required the seller to repair or replace the goods, but the seller is in breach of the requirement of section 48B(2)(a) above to do so within a reasonable time and without significant inconvenience to the buyer.

(3) For the purposes of this Part, if the buyer rescinds the contract, any reimbursement to the buyer may be reduced to take account of the use he has had of the goods since they were delivered to him.

S. 48F. Conformity with the contract
For the purposes of this Part, goods do not conform to a contract of sale if there is, in relation to the goods, a breach of an express term of the contract or a term implied by section 13, 14 or 15 above.

PART VI - ACTIONS FOR BREACH OF THE CONTRACT

S. 51. Damages for non-delivery
(1) Where the seller wrongfully neglects or refuses to deliver the goods to the buyer, the buyer may maintain an action against the seller for damages for non-delivery.

(2) The measure of damages is the estimated loss directly and naturally resulting, in the ordinary course of events, from the seller's breach of contract.

(3) Where there is an available market for the goods in question the measure of damages is prima facie to be ascertained by the difference between the contract price and the market or current price of the goods at the time or times when they ought to have been delivered or (if no time was fixed) at the time of the refusal to deliver.

S. 53. Remedy for breach of warranty
(1) Where there is a breach of warranty by the seller, or where the buyer elects (or is compelled) to treat any breach of a condition on the part of the seller as a breach of warranty, the buyer is not by reason only of such breach of warranty entitled to reject the goods; but he may—

(a) set up against the seller the breach of warranty in diminution or extinction of the price, or

(b) maintain an action against the seller for damages for the breach of warranty.

(2) The measure of damages for breach of warranty is the estimated loss directly and naturally resulting, in the ordinary course of events, from the breach of warranty.

(3) In the case of breach of warranty of quality such loss is prima facie the difference between the value of the goods at the time of delivery to the buyer and the value they would have had if they had fulfilled the warranty.

(4) The fact that the buyer has set up the breach of warranty in diminution or extinction of the price does not prevent him from maintaining an action for the same breach of warranty if he has suffered further damage.

(5) This section does not apply to Scotland.

PART VII - SUPPLEMENTARY

S. 61. Interpretation
(1) In this Act, unless the context or subject matter otherwise requires—

...

"warranty" (as regards England and Wales and Northern Ireland) means an agreement with reference to goods which are the subject of a contract of sale, but collateral to the main purpose of such contract, the breach of which gives rise to a claim for damages, but not to a right to reject the goods and treat the contract as repudiated.

...

MISREPRESENTATION ACT 1967 ('MA')

S. 1. Removal of certain bars to rescission for innocent misrepresentation
Where a person has entered into a contract after a misrepresentation has been made to him, and—

(a) the misrepresentation has become a term of the contract; or

(b) the contract has been performed;

or both, then, if otherwise he would be entitled to rescind the contract without alleging fraud, he shall be so entitled, subject to the provisions of this Act, notwithstanding the matters mentioned in paragraphs (a) and (b) of this section.

S. 2. Damages for misrepresentation

(1) Where a person has entered into a contract after a misrepresentation has been made to him by another party thereto and as a result thereof he has suffered loss, then, if the person making the misrepresentation would be liable to damages in respect thereof had the misrepresentation been made fraudulently, that person shall be so liable notwithstanding that the misrepresentation was not made fraudulently, unless he proves that he had reasonable ground to believe and did believe up to the time the contract was made that the facts represented were true.

(2) Where a person has entered into a contract after a misrepresentation has been made to him otherwise than fraudulently, and he would be entitled, by reason of the misrepresentation, to rescind the contract, then, if it is claimed, in any proceedings arising out of the contract, that the contract ought to be or has been rescinded the court or arbitrator may declare the contract subsisting and award damages in lieu of rescission, if of opinion that it would be equitable to do so, having regard to the nature of the misrepresentation and the loss that would be caused by it if the contract were upheld, as well as to the loss that rescission would cause to the other party.

(3) Damages may be awarded against a person under subsection (2) of this section whether or not he is liable to damages under subsection (1) thereof, but where he is so liable any award under the said subsection (2) shall be taken into account in assessing his liability under the said subsection (1).

LIMITATION ACT 1980 ('LA')

PART I - ORDINARY TIME LIMITS FOR DIFFERENT CLASSES OF ACTION

S. 5. Time limit for actions founded on simple contract

An action founded on simple contract shall not be brought after the expiration of six years from the date on which the cause of action accrued.

PART II - EXTENSION OR EXCLUSION OF ORDINARY TIME LIMITS

S. 32. Postponement of limitation period in case of fraud, concealment or mistake

(1) Subject to subsections (3) and (4A) below, where in the case of any action for which a period of limitation is prescribed by this Act, either—

(a) the action is based upon the fraud of the defendant; or

(b) any fact relevant to the plaintiff's right of action has been

deliberately concealed from him by the defendant; or

(c) the action is for relief from the consequences of a mistake;

the period of limitation shall not begin to run until the plaintiff has discovered the fraud, concealment or mistake (as the case may be) or could with reasonable diligence have discovered it.

TRADE DESCRIPTIONS ACT 1968

S. 1. Prohibition of false trade descriptions
(1) Any person who, in the course of a trade or business,—

(a) applies a false trade description to any goods; or

(b) supplies or offers to supply any goods to which a false trade description is applied;

shall, subject to the provisions of this Act, be guilty of an offence.

…

S. 2. Trade description
(1) A trade description is an indication, direct or indirect, and by whatever means given of any of the following matters with respect to any goods or parts of goods, that is to say—

(a) quantity, size or gauge;

(b) method of manufacture, production, processing or reconditioning;

(c) composition;

(d) fitness for purpose, strength, performance, behaviour or accuracy;

(e) any physical characteristics not included in the preceding paragraphs;

(f) testing by any person and results thereof;

(g) approval by any person or conformity with a type approved by any person;

(h) place or date of manufacture, production, processing or reconditioning;

(i) person by whom manufactured, produced, processed or reconditioned;

(j) other history, including previous ownership or use.

…

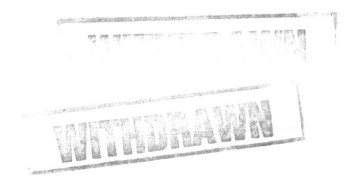